DRAWING TREES

TRACE
THIRTY
DIFFERENT
TREES
AND THEIR
LEAVES,
BRANCHES,
AND SEEDS

PRINCETON ARCHITECTURAL PRESS · NEW YORK

How to use
this book

TRACING

STEP 1

Skim through the book and see which drawings
call to you. If you are new to drawing, consider
starting simply. You can use the pages in this book
as you wish–use some of the empty space to doodle,
write notes, or warm up.

STEP 2

Choose a drawing tool. Any drawing or writing
implement will do, but a fine-point pen or freshly
sharpened graphite or colored pencil will help
you define details.

STEP 3

Draw mindfully and observe your drawing come
to life. You can just stick to tracing the outlines, or
you can get creative and play with shading, color,
filling in shapes, or whatever else you come up with.

PRACTICE NOTICING

Filled with mindfulness prompts, this book is made
to help you connect with the present moment. There
is power in observation, and drawing is a good way
to build the muscle of awareness.

Leaf types and shapes

CONIFER

GINKGO

DICOT

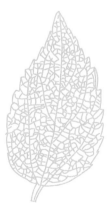

MONOCOT

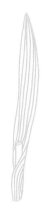

SIMPLE

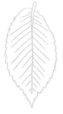

Pinnate Palmate

LOBED

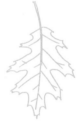 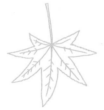

Pinnate Palmate

COMPOUND

 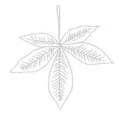

Pinnate Palmate

Tree types

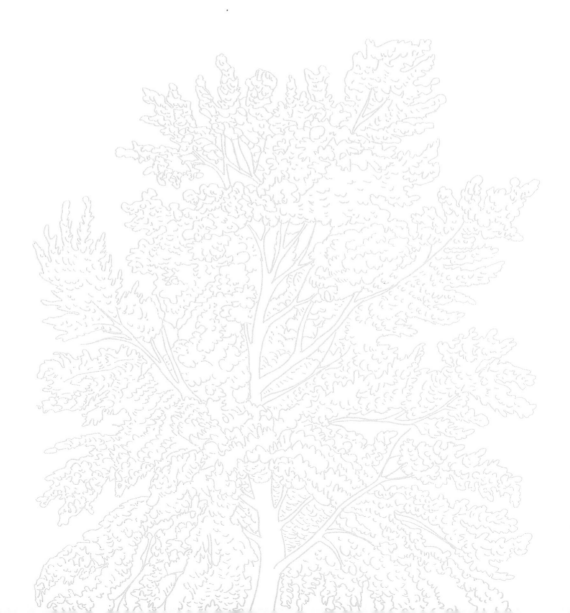

EVERGREEN

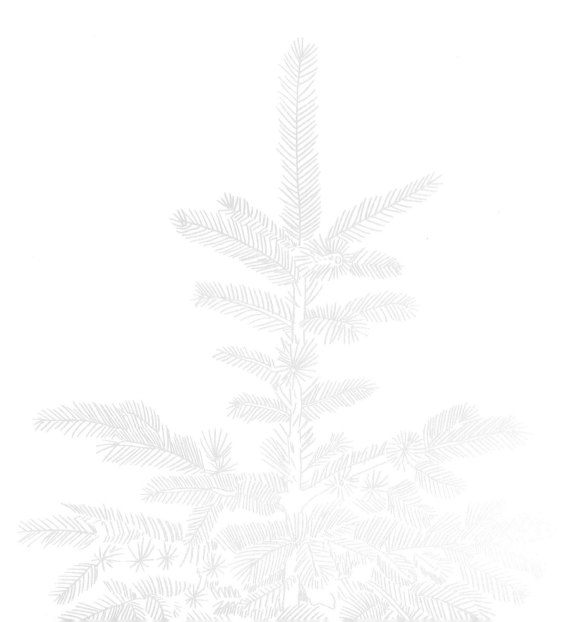

Contents

AMERICAN BEECH 12

AMERICAN CHESTNUT 16

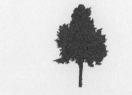

AMERICAN LINDEN 20

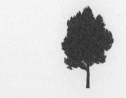

AMERICAN SYCAMORE 22

BLACK WALNUT 26

BLUE SPRUCE 28

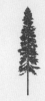

COAST REDWOOD 32

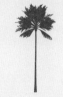

DATE PALM 34

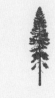

DOUGLAS FIR 36

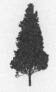

EASTERN ARBORVITAE 40

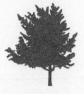

GINKGO 44

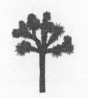

JOSHUA TREE 46

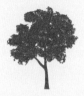

KENTUCKY COFFEETREE 52

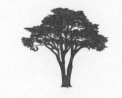

MONTEREY CYPRESS 54

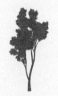

PACIFIC MADRONE 58

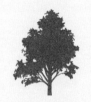

PAPER BIRCH 60

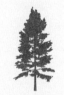

PONDEROSA PINE 62

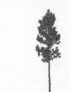

QUAKING ASPEN 64

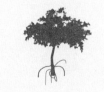

RED MANGROVE 68

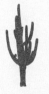

SAGUARO CACTUS 70

SASSAFRAS 72

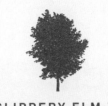

SLIPPERY ELM 74

SUGAR MAPLE 76

SWEET CRAB APPLE 80

SWEETGUM 84

TULIP TREE 86

WEEPING WILLOW 90

WHITE ASH 92

WHITE OAK 94

WILD PLUM 98

American Beech

Fagus grandifolia

A beech tree takes its time. It grows slowly and its canopy spreads wide. Because the tree prefers fertile soil, early North American settlers learned quickly to seek it out: where a beech grew, they could plow and farm. Sadly, that meant they removed a lot of beeches, and the trees were slow to come back. Beeches were once a favorite place of rest for migrating passenger pigeons. Legend has it that so many pigeons used to rest on the United States' beeches that the trees' limbs would break under the weight of the birds.

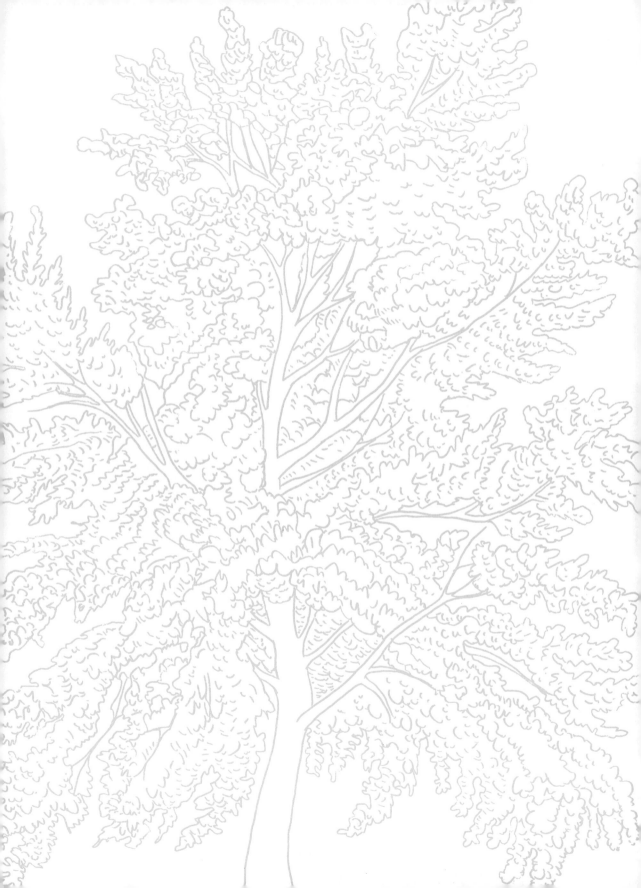

PRACTICE NOTICING

Before you begin, take a piece of scrap paper and the nearest pen, pencil, marker, or anything else to make marks with. Simply start by drawing a few lines or scribbles. No one is watching. This is your warm-up. You can begin this practice any time and return to it any time. It may feel silly or freeing, but no matter what you feel, keep going.

American beech leaves and seeds

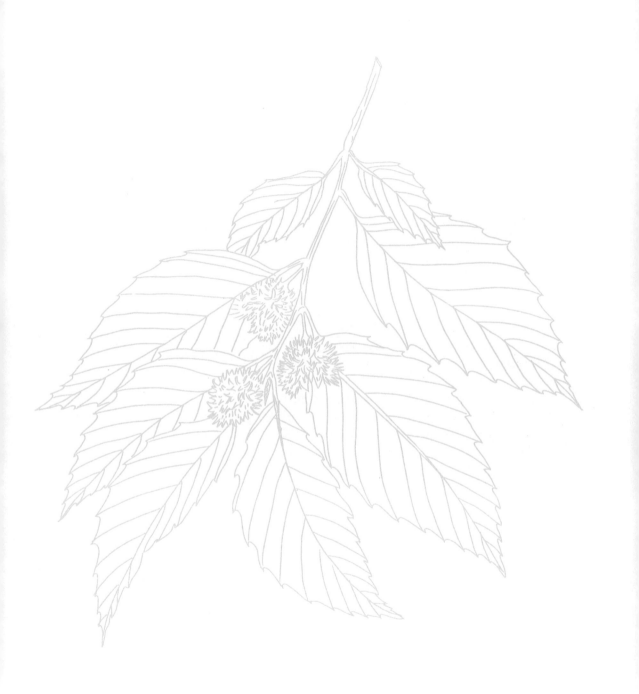

American Chestnut

Castanea dentata

Once upon a time, the forests of North America were rich with chestnut trees. Their sweet nuts were a favorite among animals and people. Their light, rot-resistant wood made them popular among builders and furniture makers, and they could grow to more than a hundred feet tall. In the 1930s, however, the species was so decimated by the invasive fungal disease chestnut blight that we know of not even a hundred adult trees in North America today, and those have rarely grown to even thirty feet. The American Chestnut Foundation, an ecological nonprofit, works on reestablishing the United States' native chestnut population.

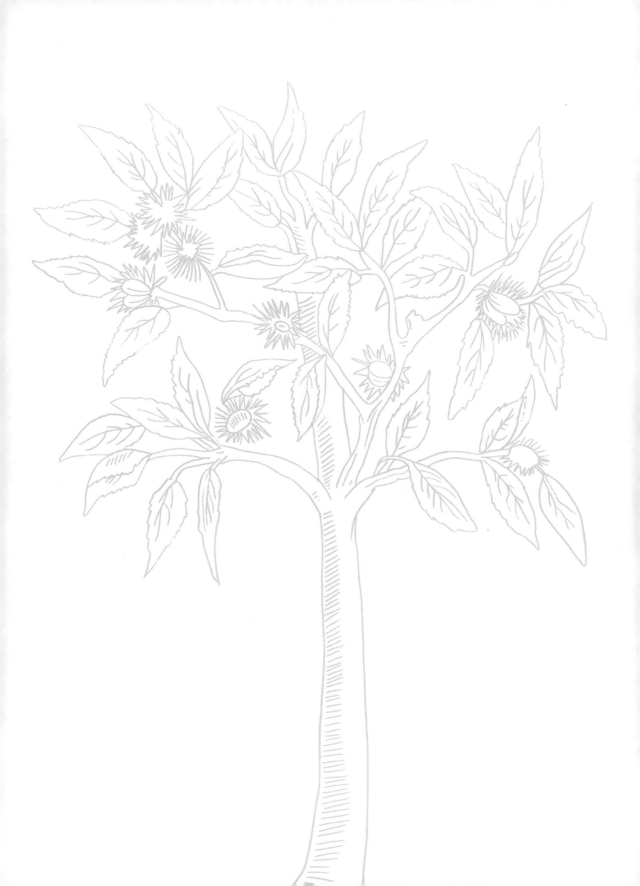

PRACTICE NOTICING

Take a deep breath, and sit quietly for one or two minutes (you can set a timer if you like). With eyes open or closed, notice your in breath and out breath, and feel the chair or floor supporting you. Notice the sounds around you and any other sensations and thoughts that occur. The goal is not to clear your mind but rather to be in touch with the present moment, including your awareness of whatever arises.

American chestnut leaves, flowers, fruit, and nut

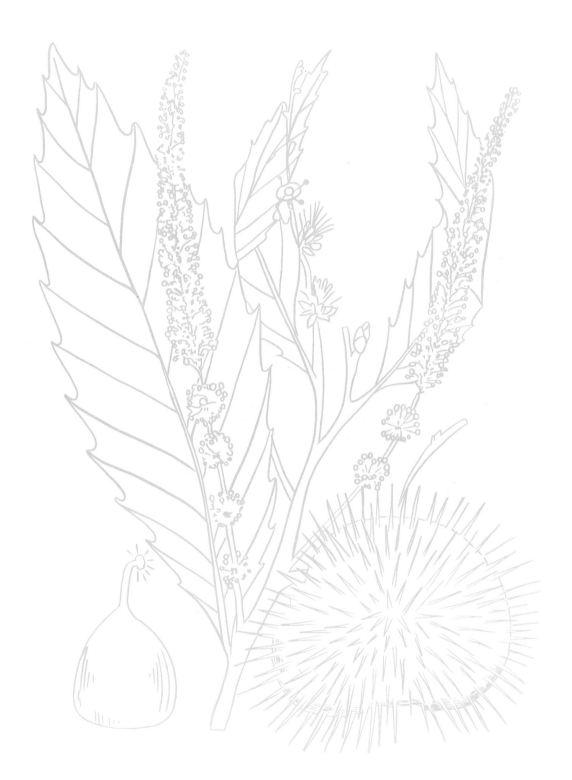

American Linden

Tilia americana

If the American linden had a slogan, it might be "Live fast, die young." The sole example of its genus in all the Western Hemisphere, it is among the fastest-growing North American hardwood trees. It grows twice as fast as many birches and beeches, only to die at the relatively young age of around two hundred. But if life is quick for the American linden, it is also sweet: many find its heart-shaped leaves delicious when they're young and tender, and the linden's aromatic flowers, rich in antioxidants and flavonoids, yield a pleasing, spicy honey.

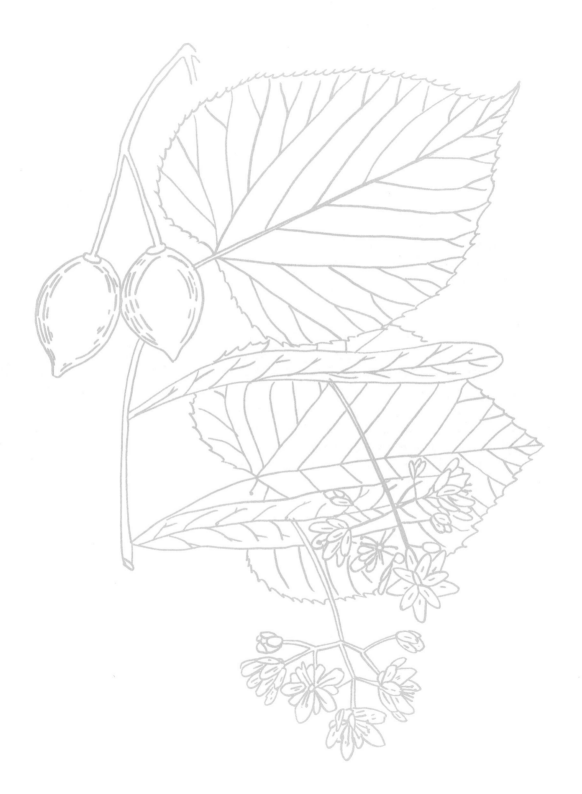

American Sycamore

Platanus occidentalis

The American sycamore goes by many names,
including plane tree, water beech, buttonball, and
buttonwood. (Fun fact: the terms of the New York
Stock Exchange are called the Buttonwood Agreement
because they were named after a sycamore tree on
Wall Street.) Its many names are not its only way of
going undercover; take a quick glance at its leaves, and
you might mistake it for a maple tree. The difference
is in the sycamore's distinctive trunk and limbs:
the American sycamore likes to dress head to toe
in camouflage–its stretched bark a uniquely visible
record of its growth–jigsaw pattern of cream colors,
light browns, and greens.

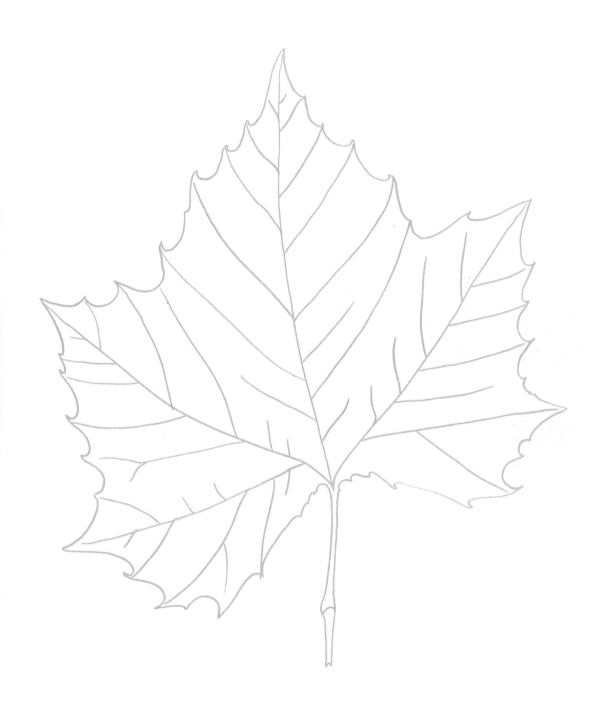

Notice what kind of resistance you feel when drawing. Are you thinking about the end result and how much time it will take you to complete the drawing? Do you feel uncertain about it being good enough? Feel the resistance and draw anyway.

Distinctive American sycamore bark

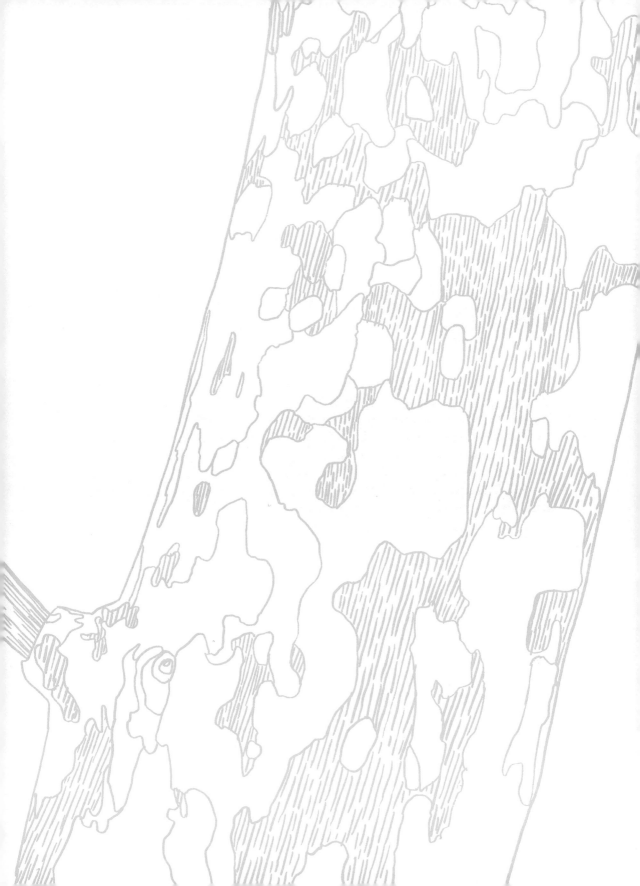

Black Walnut

Juglans nigra

The luxurious black walnut tree grows slowly, in full sun. Its heartwood is highly valued for its deep color, durability, and grain, and it is often harvested for woodworking and veneers. Its nuts, though edible, are not to be confused with the lighter-colored, orchard-cultivated English walnuts you might buy at a grocery store. Black walnuts, the only all–wild tree nuts in the United States, have a rich, bold flavor. Their extracts can be used as a natural dye, and their tannins make good ink, wood stain, and mordant in the dyeing process.

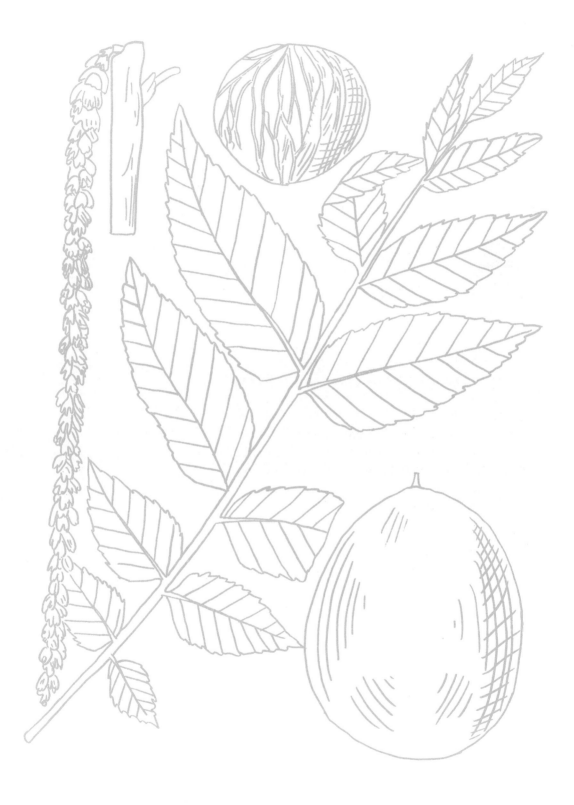

Blue Spruce

Picea pungens

One of seven varieties of spruce that happen to be native to the United States, the blue spruce's scientific name is *Picea pungens*, which in Latin means "sharply pointed." Indeed, anyone who's brought home a blue spruce as a Christmas tree can attest to the prickliness of its inch-long, blue- or silver-green needles. The tree is not only dear to descendants of Christian colonists, however. Navajo and Keres people have long used it both ceremonially and medicinally, giving twigs of blue spruce as gifts to bring good fortune and drinking infusions of the needles to treat colds, rheumatism, and upset stomachs.

To forget how to dig the earth
and tend the soil
is to forget ourselves.

—Mahatma Gandhi (1869–1948)

Coast Redwood

Sequoia sempervirens

Because the hardy, low-resin wood of the redwood is resistant to water, fire, and decay, it has long been used in the California railroad and throughout the West Coast for architecture and furniture, but these beloved giants are better known for their majesty in nature. Redwoods—which regularly live for two thousand years and grow to 150 feet—are among the tallest living things on Earth and the longest living. One Northern California tree, nicknamed Hyperion, towers over its neighbors at 380 feet. Its exact location is kept a secret by Redwood National Park, to protect it from would-be climbers and other tourists.

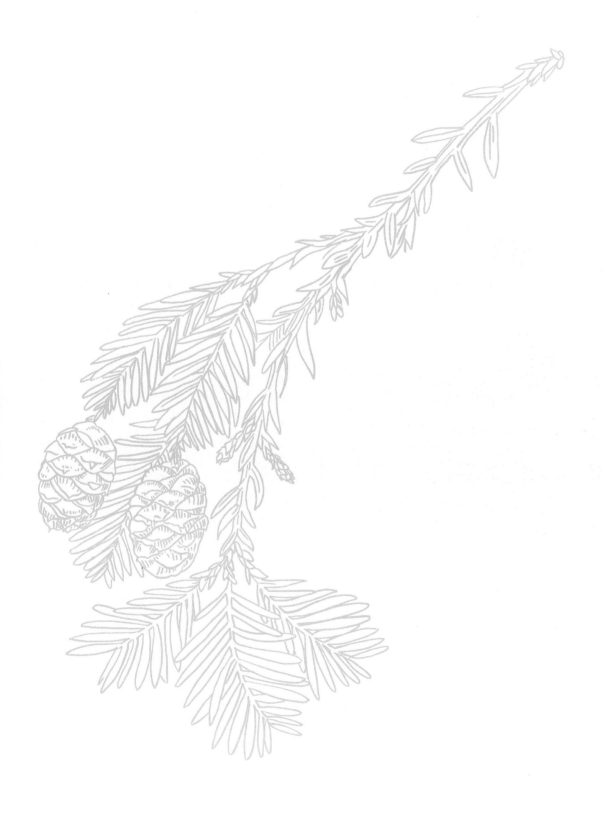

Date Palm

Phoenix dactylifera

In ancient times, the date palm represented fertility and life. Due to the raylike arrangement of its leaves, the Egyptians, Greeks, and Romans all associated it with the sun. In Rome its fronds were used in triumphal processions. For ancient Jews it was a symbol of sweetness and peace. Today, the date palm, which annually can bear hundreds of pounds of fruit, signifies luxury and abundance. Though not native to the United States, it is grown commercially and decoratively in the Mediterraneanesque climates of the West and Southwest of the United States.

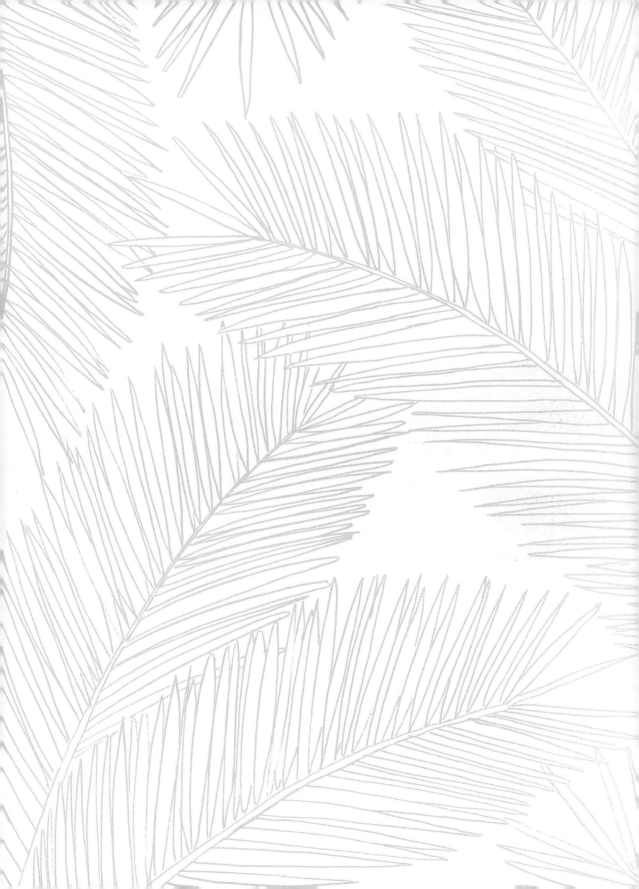

Douglas fir

Pseudotsuga menziesii

The Douglas fir is not a fir. Nor is it a hemlock (its genus name, *Pseudotsuga*, means "false hemlock"). Despite its name, it is a type of pine. Commonly adopted as a Christmas tree, it is also the United States' most popular timber tree, and it's the only wood still used in shipbuilding (see: US Navy minesweepers). The Douglas fir is just as important within the forest: its needles, seeds, and inner bark are a primary food source for moles, shrews, chipmunks, grouse, porcupines, and deer, and old-growth Douglas fir trees make good homes for owls and voles.

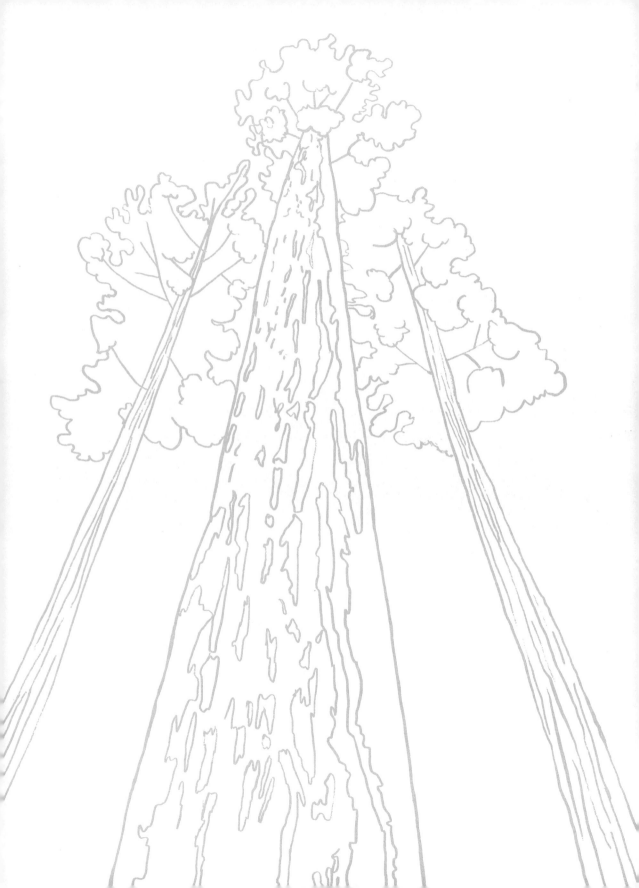

PRACTICE NOTICING

Where does your mind wander when you draw? Notice the character of your thoughts. Are they positive? Negative? Neutral? Do they wander to the past or the future? Welcome any and all states of mind as you pass in and out of your awareness of thinking.

Douglas fir leaves and cone

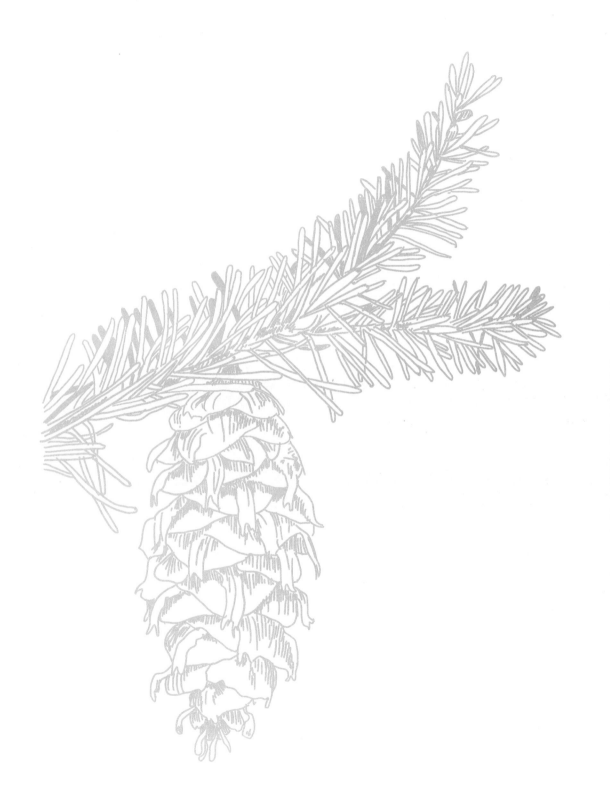

Eastern Arborvitae

Thuja occidentalis

The Latin name *Arborvitae* translates to "tree of life,"
and the name is apt. This family of cedars can live
to more than a thousand years old, notwithstanding
inhospitable conditions. They thrive, for instance, on
the sides of cliffs and can survive serious damage. The
first native North American tree to be introduced to
Europe, the arborvitae figures deeply in the lore and
legends of the Ojibwe, who refer to it as Grandmother
Cedar. Its bark can be used in medicines; its wood
in construction. The species's genus name is *Thuja*,
which is derived from a Greek word for "perfume."
Squeeze the tiny fan-shaped sprays to release their
sweet aroma.

PRACTICE NOTICING

As you draw, notice what thoughts and feelings come into your mind. Are there "shoulds" and "ought tos?" Are you enjoying yourself but feel like you should be doing something else? Do you get so into it that you lose track of time or place—in other words, are you in the flow? Is there joy, freedom, escape? Do you feel anxious or distracted? All thoughts and emotions are valid and welcome; there is no right or wrong way to feel.

Eastern arborvitae leaf and flowers

Ginkgo

Ginkgo biloba

The *Ginkgo biloba* is one of the world's most ancient
trees: fossilized leaves dating back 270 million years
show that it has barely changed since the Paleozoic
era. Approximately two million years ago, however,
ginkgoes disappeared from the fossil record altogether.
Indeed, the ginkgo no longer grows in the wild.
It was saved from extinction by human cultivation
in Asia, where it is used medicinally, ceremonially,
and ornamentally. Today, its tolerance for pollution
makes it a common sight on city streets worldwide.
Its unique fanlike leaves turn golden in the fall and
pile up curbside.

Joshua Tree

Yucca brevifolia

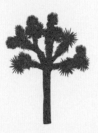

The Joshua tree has many names. Sometimes it's called a yucca palm. In Spanish it's referred to as the *izote de desierto* (desert dagger). The southwestern Cahuilla–who use it for cooking, weaving, roofing, dyeing, medicines, and more–call it *hunuvat chiy'a*. Legend has it that the name Joshua was given to it by Mormon pioneers, for whom the wide-armed branches recalled a person praying or pointing the way to the Promised Land. Whatever you call it, it is a survivor: its top-heavy branches are counterbalanced by a broad root system. Despite drought, heat, and wind, it can survive for a thousand years.

PRACTICE NOTICING

Concentration, like drawing, is a practice. In concentration meditation, we can find space from the repetitive thoughts of daily life. When we keep our attention steady on the object we are drawing, we can reach a state of focus. This is not to say that our minds won't wander—they will—but we can use our drawing practice to return to the present moment. Notice when your mind has drifted from drawing, and gently guide your attention back to the page. With practice, your mind will stay in a concentrated state for longer periods of time.

Joshua tree

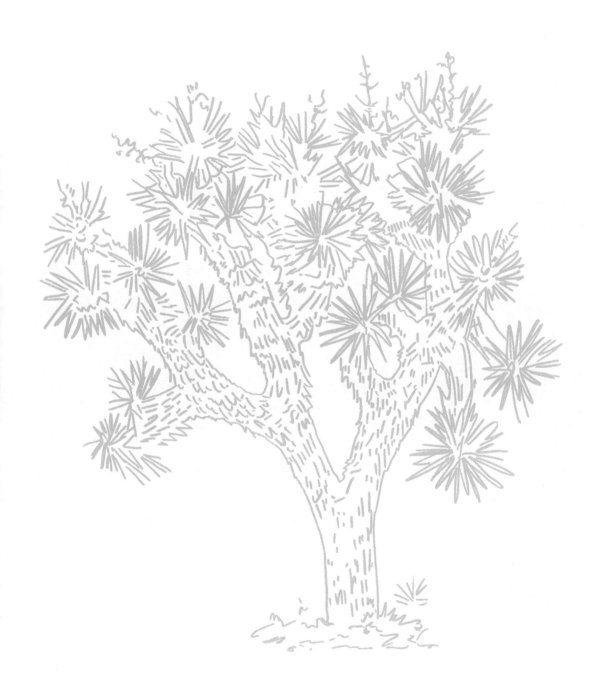

In the spring, at the end of the day,
you should smell like dirt.

—Margaret Atwood

Kentucky Coffeetree

Gymnocladus dioicus

The hard black seeds of the Kentucky coffee tree are poisonous and will not germinate until their coats are dissolved. In prehistoric times, the now-extinct megafauna did the job of eating them and soaking them in stomach acid, rendering them viable before releasing them into the landscape. Some Native American peoples roasted the seeds to enjoy them safely; the Ho-Chunk, Pawnee, and Meskwaki also used them in games and wore them ornamentally. The Meskwaki roasted and brewed the seeds in hot water. When they showed European colonists how to use the tree's seeds in this way, the English speakers named it after a similar hot beverage: coffee.

Monterey Cypress

Cupressus macrocarpa

The rare and hardy Monterey cypress makes a picturesque sight on the rocky headlands of the California coast, where Pacific airstreams leave it flat topped and wind sculpted. It is common, too, in blustery seaside areas of Europe, South Africa, Australia, and New Zealand, where it's referred to as *macrocarpa*. Due to its ability to endure a serious buffeting, the Monterey cypress is often used in landscaping as a windbreak. Stand nearby as a breeze blows through its branches to smell the lemony aroma of its dense, scaly foliage.

Take this book with you to a favorite place or one you've always wanted to visit. It should be a place that feels restorative in some way. As you connect to what's on the page, enjoy being at your spot, doing something that engages your mind and hands. Be present with the sights and sounds around you, and notice how being at this place affects your drawing.

Monterey cypress

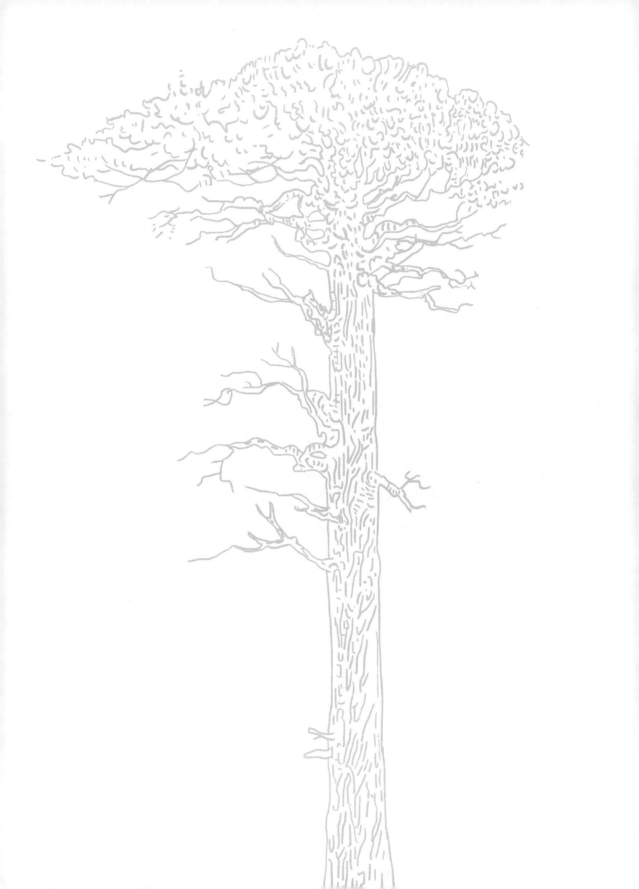

Pacific Madrone

Arbutus menziesii

The red bark, tan trunk, pale flowers, and clustering fire-colored berries make the Pacific madrone–sometimes called a bearberry tree–one of the United States' most attractive. But the madrone is more than just a pretty face. Native Americans ate its plentiful berries raw and cooked, made them into cider, and used its bark medicinally to treat a variety of ailments. This tree is a preferred nesting spot for many species of birds, and because the madrone's berries keep growing through the winter, it's also an increasingly valuable food source for many animals as the seasons change.

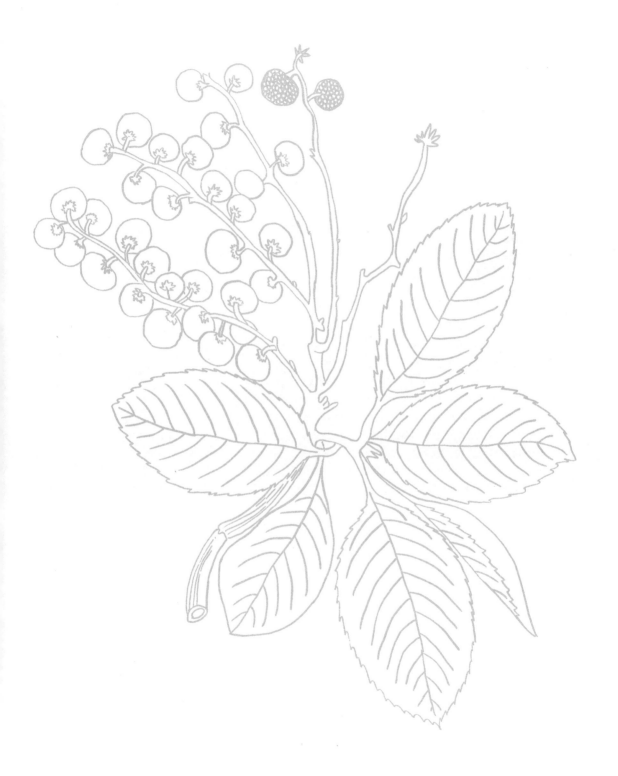

Paper Birch

Betula papyrifera

Approximately eighteen species of birch tree claim North America as their native home, but the paper birch is the most populous. It is named for its bark, which curls and peels from its trunk like paper and has been used as a creative medium by indigenous craftspeople and artists. The Anishinaabe construct boxes from birch bark called *wiigwaasi-makak*. The Abenaki use it for canoes, containers, and wigwams. Some artists among the Anishinaabe, Cree, and Algonquian peoples practice birch-bark biting, an artform wherein dental impressions on thin swaths of bark leave an intricate translucent design or lace.

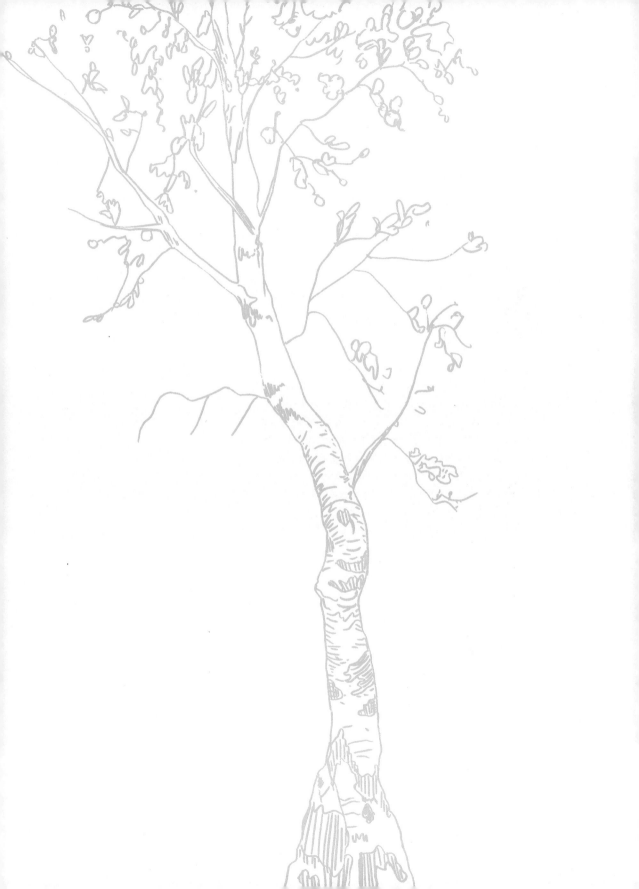

Ponderosa Pine

Pinus ponderosa

There are forty-one species of pine in North America, but the ponderosa is the most far-flung. It is also known as western yellow or red pine, bull pine, rock pine, and blackjack pine; the latter is a nickname given by early loggers for the color of young ponderosa's bark, so dark brown it's almost black. The prevalence of the ponderosa is rivaled only by its usefulness. Wildlife, from chipmunks and squirrels to quail and nutcrackers, consume its seeds. Humans use its wood for lumber and paper pulp and distill its sap into turpentine, pitch, and resin.

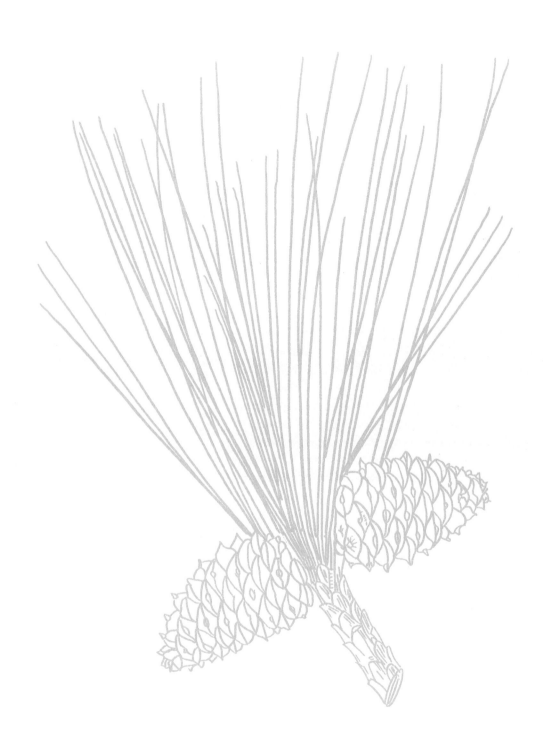

Quaking Aspen

Populus tremuloides

Don't be fooled by its timid name and tremulous diamond-shaped leaves. The quaking aspen is hardy – and a record breaker. Spanning nine time zones, half the globe's latitude, and many miles of elevation, it boasts the widest range of any tree in North America. Since it breeds not by reproduction but by cloning–sprouting new trees from existing root structures–multiple groves can be thought of as parts of the same plant. The world's largest living organism, it is also among the oldest: a 108-acre colony of forty thousand quaking aspens in Utah is estimated to be fourteen thousand years old.

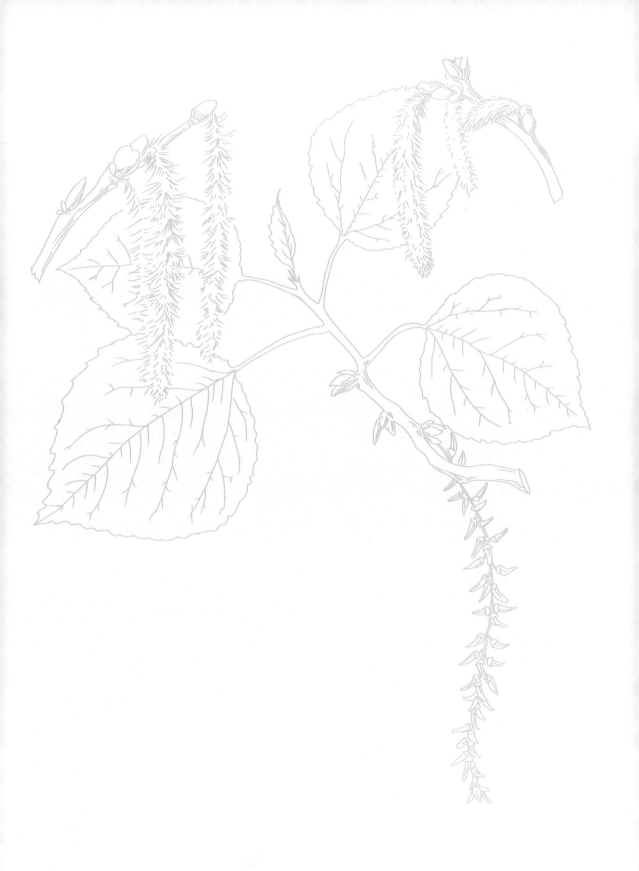

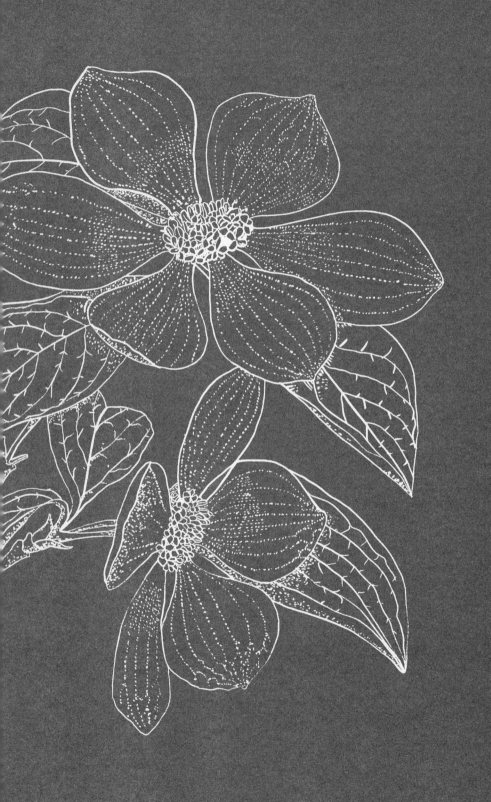

Earth laughs in flowers.

—Ralph Waldo Emerson (1803–1882)

Red Mangrove

Rhizophora mangle

The tropical mangrove flourishes in estuaries in Louisiana, Texas, and Florida, along the southern Gulf Coast. These unusual trees' stilt-like roots, or rhizophores, not only anchor them in shifting sediment, high winds, and tidal waters but also support a vibrant ecosystem of aquatic life. Human engineers have used the mangrove's natural filtration system, which converts salty water into nearly salt-free sap, as a model for commercial desalination. And strangely enough, unlike most trees, mangroves bear live young. Seedlings germinate almost like tree limbs. The spears–called propagules or sea pencils–detach and take root when they're approximately a foot long.

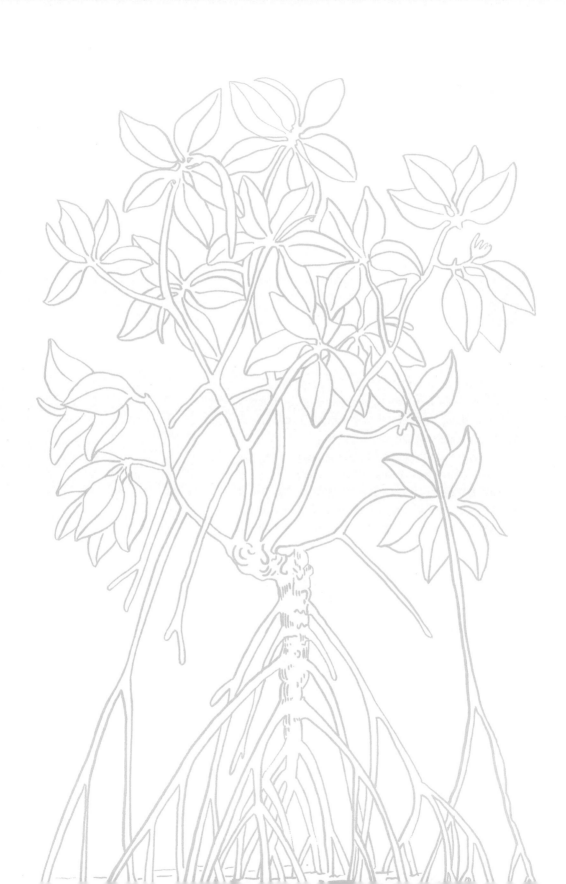

Saguaro Cactus

Carnegiea gigantea

Is the great saguaro technically a tree? Some say no, since in place of leaves, bark, and twigs, it has spines as sharp and strong as steel needles. Others say yes, citing its single trunk and impressive height: this southwestern succulent can grow to more than forty feet. A keystone species, fully hydrated saguaro cacti can weigh thousands of pounds and are a valuable source of shelter, food, and water for hundreds of desert creatures. For the Tohono O'odham, intoxication by saguaro wine was considered holy. Other native peoples, like the Pima and Seri, still use every part of the plant.

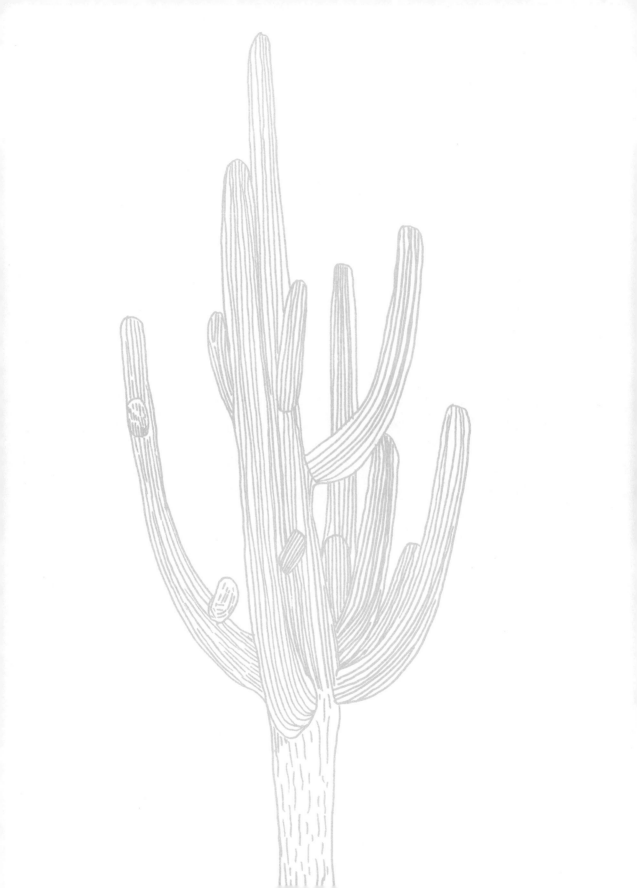

Sassafras

Sassafras albidum

The captivating sassafras–also known as
cinnamonwood or mitten leaf–is best known for
having been the original flavoring in root beer,
but its role in American medicines and cuisines is
centuries long and multiethnic. The Choctaw dried
and ground sassafras leaves to use as a seasoning
and thickener. Cajun and Creole cooks adopted
those methods for gumbo and other stews.
A fourteenth-century Spanish doctor pronounced
sassafras a miracle cure. According to one (almost
certainly apocryphal) legend, the tree's spicy
fragrance led Christopher Columbus to America;
centuries later, during Prohibition, bootleggers
used it to disguise the scent of moonshine.

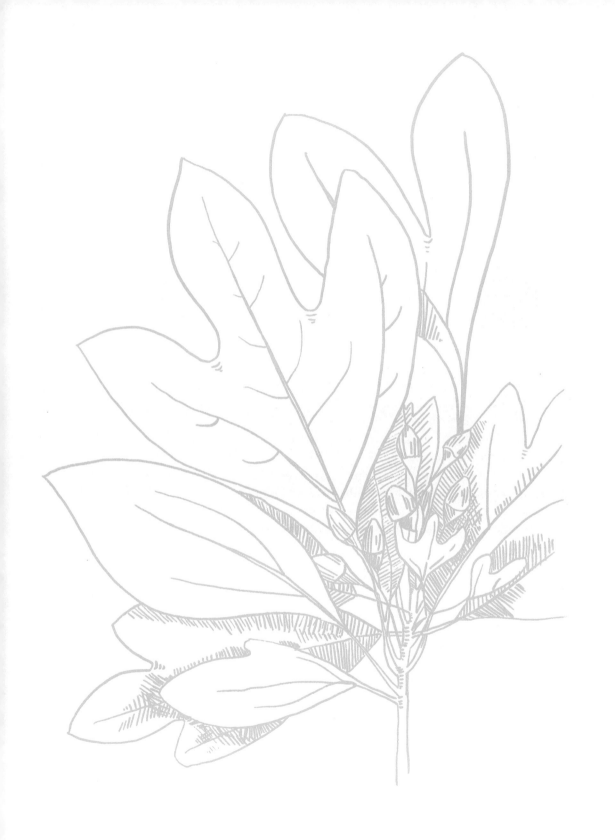

Slippery Elm

Ulmus rubra

Q: What makes the slippery elm so slippery?
A: Its aromatic, mucilaginous inner bark, which
can be eaten and made into tea, woven into thread,
twine, and rope, and used as a salve or demulcent
to soothe irritations of the skin.
Q: How American is the slippery elm? A: As American
as baseball and the Liberty Bell. Spitball pitchers used
to chew slippery elm tablets to thicken the saliva they
used to throw curveballs. The yoke of the Liberty Bell
was made from the wood of this fine tree.

Sugar Maple

Acer saccharum

The beloved sugar maple has many uses. Native peoples have long made its wood into tools and furniture, its bark into medicines. Its ashes can be used in soap, its bark for dye, and its hardwood is a favorite for bowling alleys, basketball courts, and guitars. Look to the tree's name for a hint at its most delicious purpose: maple syrup. But before you go tapping the nearest maple, know it will be slow going. Because sugar maple sap is only 2 percent sucrose, one gallon of syrup requires boiling down forty gallons of sap.

PRACTICE NOTICING

Notice your overall energy. Are you racing to get
through the drawing? Are you approaching it slowly and
carefully? There is no need to change your approach;
simply recognize it and keep drawing. Tracking your
own speed can be a way to build awareness.

Sugar maple leaf and seeds

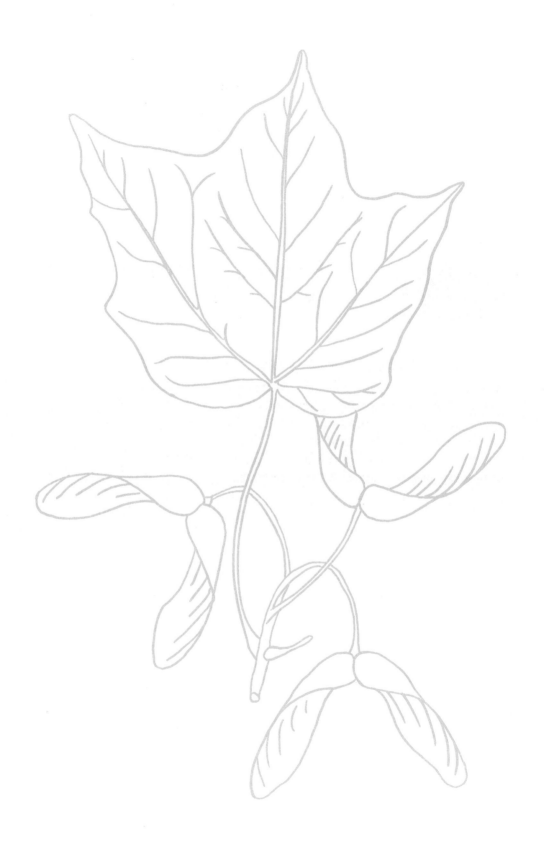

Sweet Crab Apple

Malus coronaria

This little tree, native to both North America and Asia, generally grows to no more than twenty-five feet tall. If you've seen one in the luxuriant throes of a spring bloom, it may not surprise you to learn that, technically, it is a member of the rose family. Though the fruit is small and can be quite tart, it is often made into ciders and preserves. Some even claim a preference for the sour fruit. Henry David Thoreau wrote that he liked his apples "sour enough to set a squirrel's teeth on edge and make a jay scream."

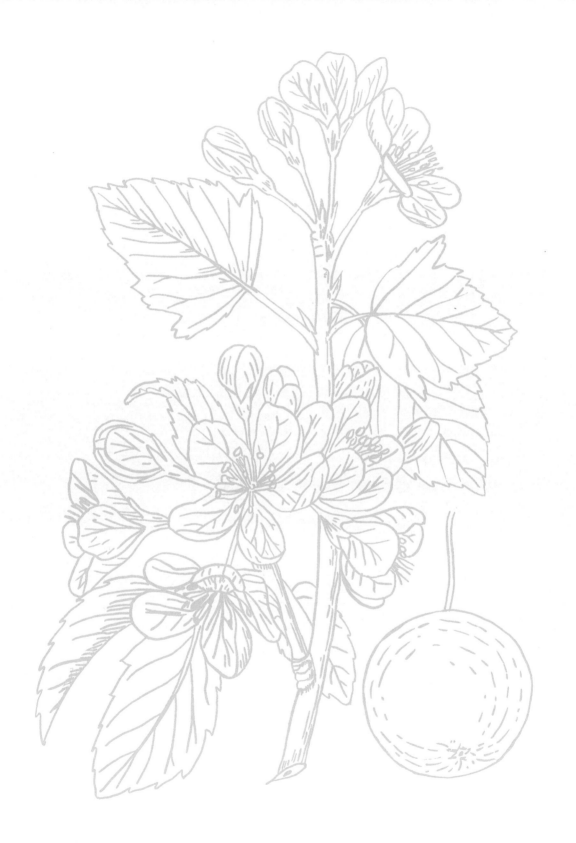

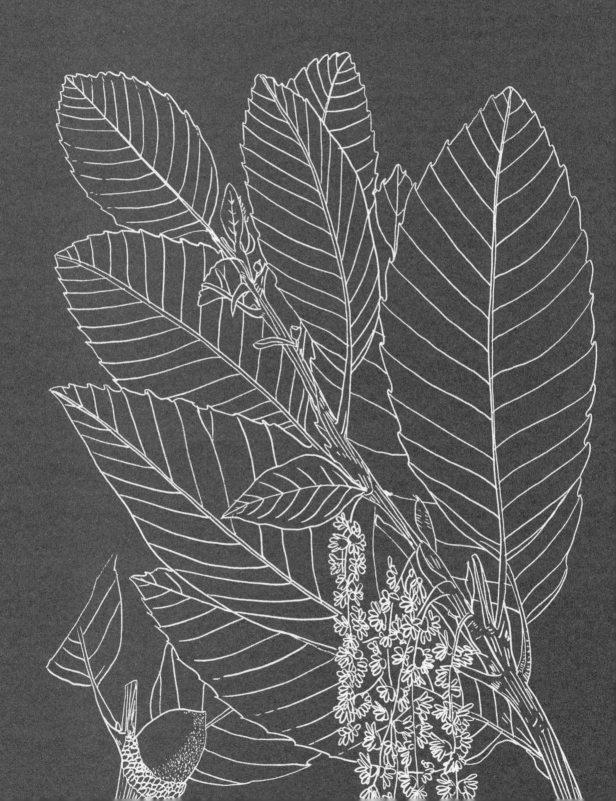

Sometimes a tree tells you more
than can be read in books.

—Carl Jung (1875–1961)

Sweetgum

Liquidambar styraciflua

The sweetgum tree is named for the fragrant, gummy resin that exudes from it when cut, which we humans have made into medicine and chewing gum. Its genus name is just as evocative as its family name and likewise derives from its balsam: in 1753, botanist-taxonomist Carl Linnaeus named it *Liquidambar*, from the Latin word for "fluid" and the Arabic for "amber." Today, the sweetgum's star-shaped leaves and hanging seed clusters are a characteristic sight in the American South. Millions of years ago, its Miocene-era ancestors populated Alaska, Greenland, Europe, and North America's midcontinental plateau.

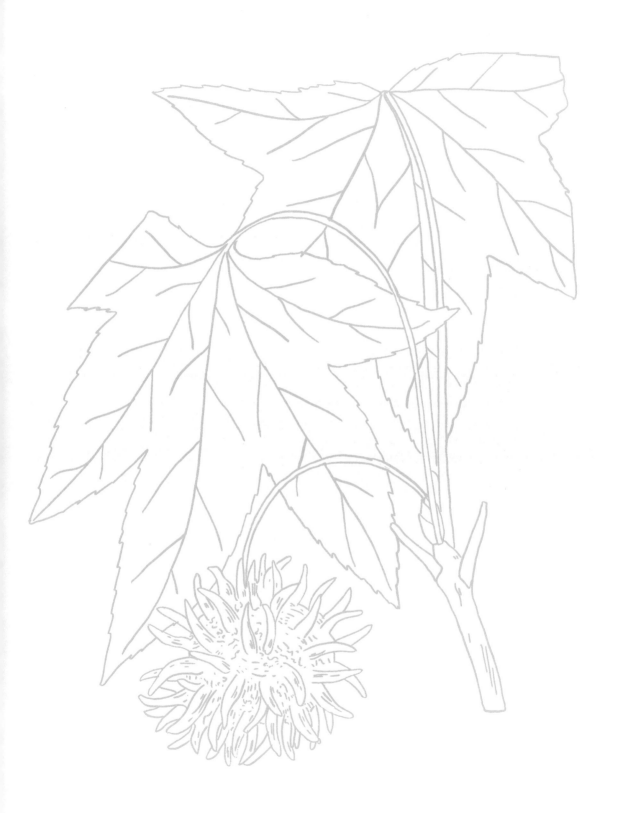

Tulip Tree

Liriodendron tulipifera

The tulip tree's eponymous flower blooms in late spring, pale green with a splash of orange at the bottom of its cup. Call it what you will—whitewood, canoewood, fiddle tree, magnolia—at one hundred million years old, it's one of Earth's oldest hardwoods. It's also among the fastest growing and, at a maximum of two hundred feet, one of the tallest. To top it all off, the tulip tree is relatively long-lived: some have lasted 350 years. Two of George Washington's tulip trees, planted in 1785, survive today at the Mount Vernon Botanical Gardens.

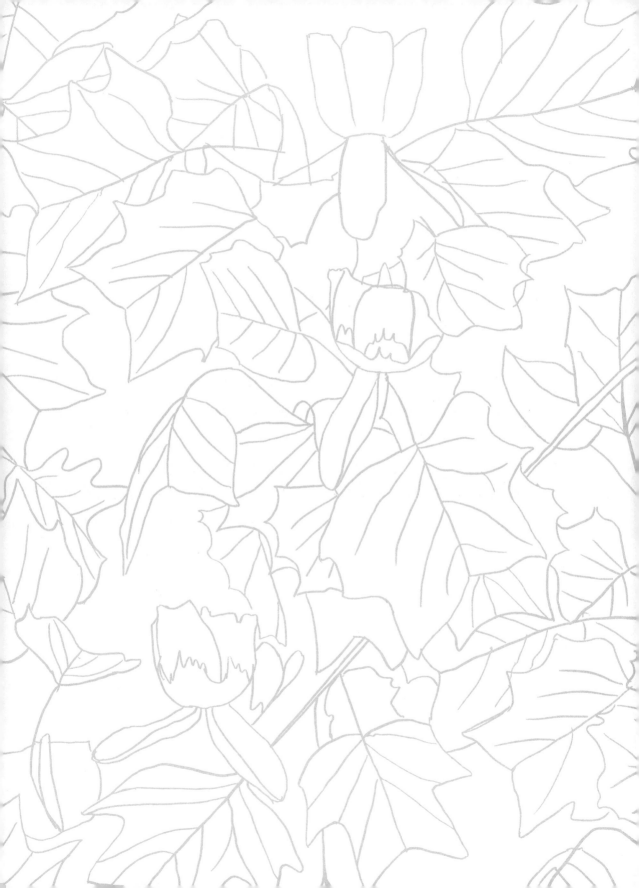

Notice how you feel about time. In our time-crunched world, it is difficult to find time to do things that feel like they are just for us. Consider setting a timer for five, ten, or thirty minutes—really, whatever you can—and let yourself get lost in the drawing. Remind yourself that you have nowhere else to go, nothing else to do: for this moment you're giving yourself over to the act of drawing.

Tulip tree flower, bud, and leaf

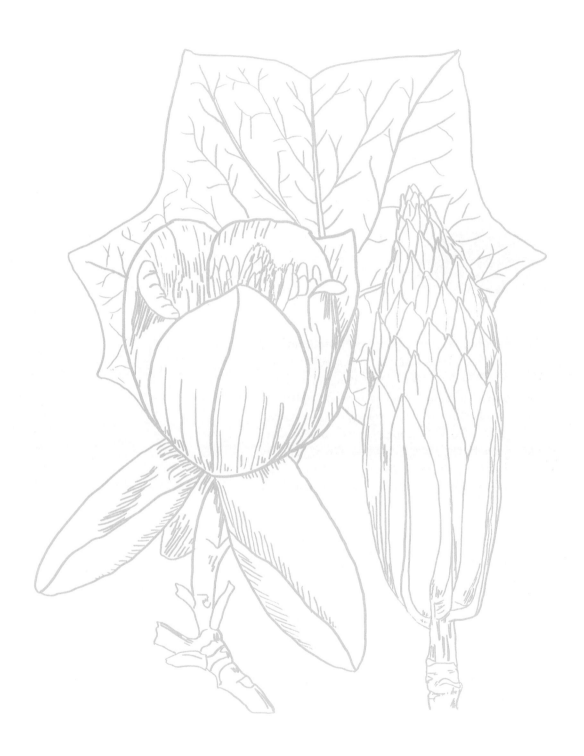

Weeping Willow

Salix babylonica

The weeping willow is native to western China but nowadays may be as common in North America as it is in Asia. Its mournful reputation belies its soothing nature: Ancient Egyptians used it to treat headaches, ancient Greeks as a more general analgesic. Medieval Europeans used it to alleviate fever, and Native Americans chew willow bark to relieve tooth pain. The USDA cites studies showing willow is an effective treatment for rheumatism and malaria. As it turns out, willow bark contains salicin, a chemical that, in the body, becomes salicylic acid, a close cousin of the active ingredient in aspirin.

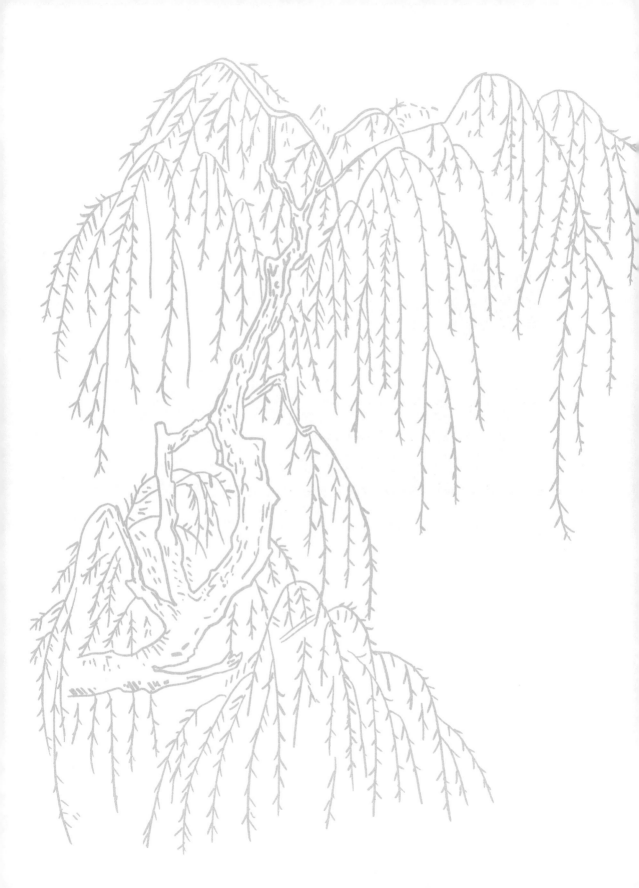

White Ash

Fraxinus americana

White ash is native to North America, and as any fan of the all-American game of baseball knows, its dense, shock-resistant wood is a favorite for bats, among other sports equipment. Named for the powdery pale undersides of its leaves in spring, the white ash is beloved for its vast range of hues in fall, when it can turn yellow, purple, or maroon. Once common from as far north as Nova Scotia to as far south as Florida, today the white ash is critically endangered due to an invasive Asian jewel beetle, the emerald ash borer.

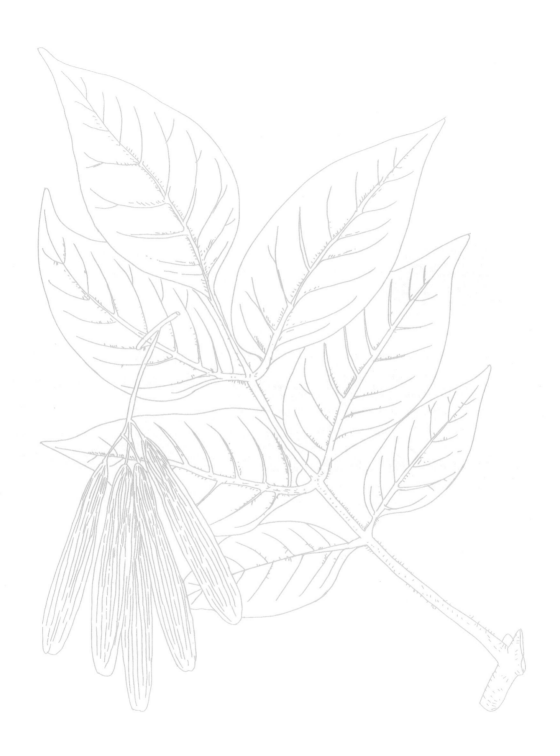

White Oak

Quercus alba

The wood of the white oak contains tissues called tyloses, which plug the microscopic gaps in its vascular cells. This makes it particularly good for sealing liquid in and out. White oak was used to build the USS *Constitution* and remains the wood of choice for wine and whiskey barrels. Among American white oaks, there are two notable celebrities: the Charter Oak of Hartford, Connecticut, in whose hollow the state's royal charter was legendarily hidden from the English in 1662 (for its patriotism, it is featured on Connecticut's state quarter); and the five-hundred-year-old Bedford Oak, which still stands in Bedford, New York.

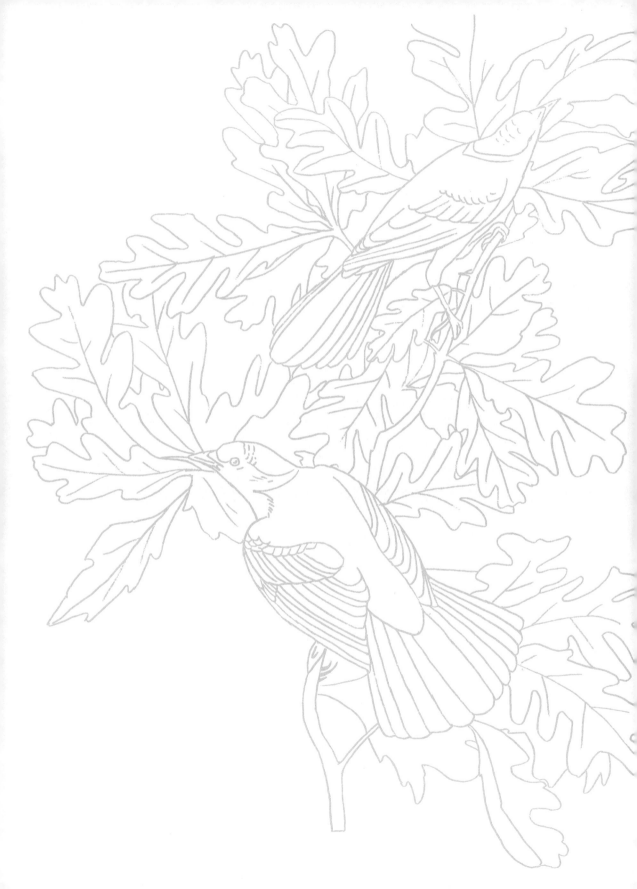

PRACTICE NOTICING

Really take the time to notice what's on the page.
Can you remove the word *tree* or *leaf* from your mind
when drawing and focus on line, space, and shape?
As you practice this, you may notice that you become
more absorbed in the act of drawing.

White oak leaf, flower, and acorn

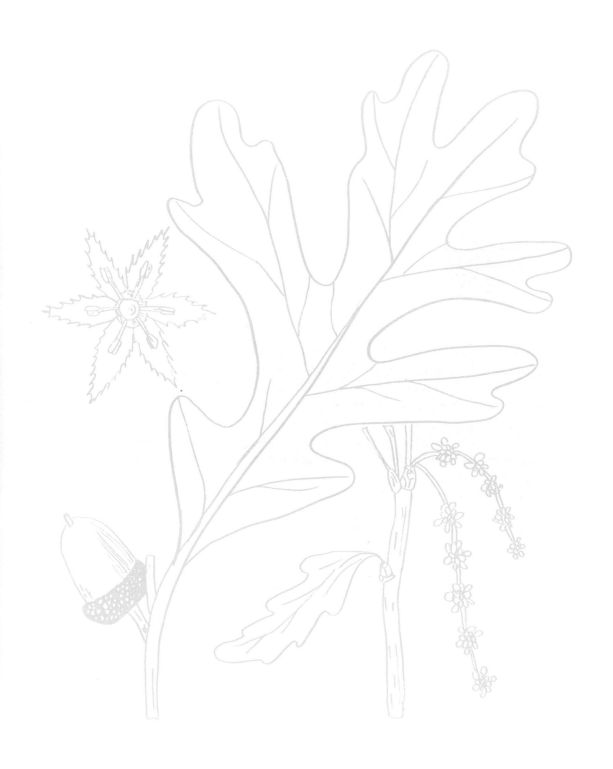

Wild Plum

Prunus americana

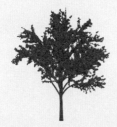

Should you eat a plum, you're likely to end up with
a commercially grown European variety, but Native
Americans and early European settlers cultivated
the wild plum. In *On the Banks of Plum Creek*, Laura
Ingalls Wilder wrote, "There were many kinds of
plums. When the red ones were all picked, the yellow
ones were ripe. Then the blue ones. The largest of all
were the very last. They were the frost plums." Today,
this thorny little fruit tree is mostly found in thickets,
hedgerows, and gardens, where it is grown for the
beauty and fragrance of its white blooms in spring.

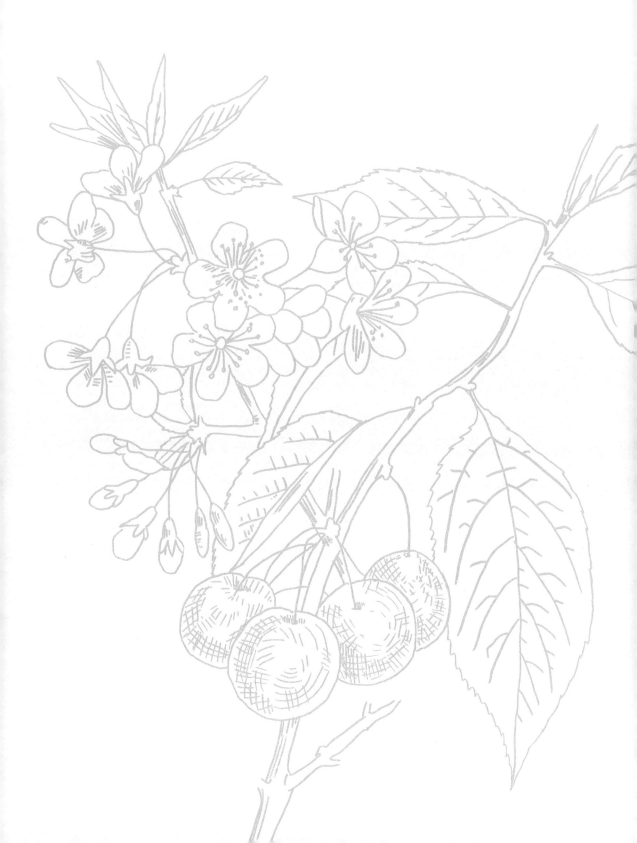

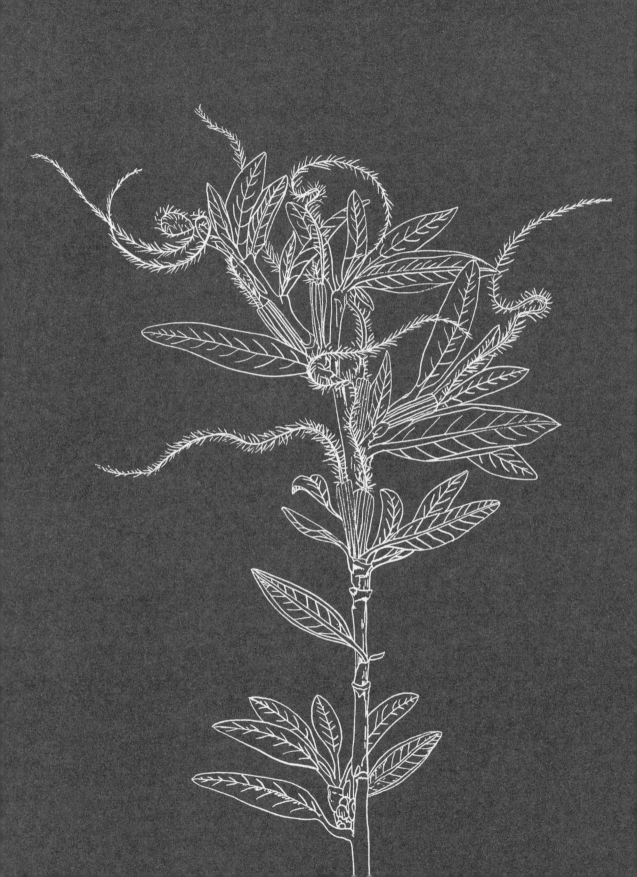

The whole starry heaven is
involved in the growth of plants.

—Rudolf Steiner (1861–1925)

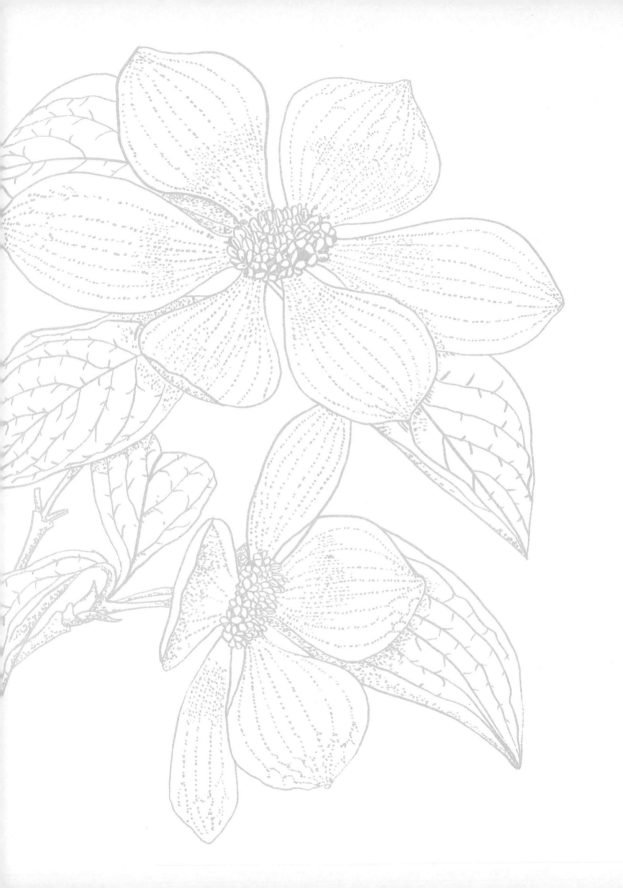

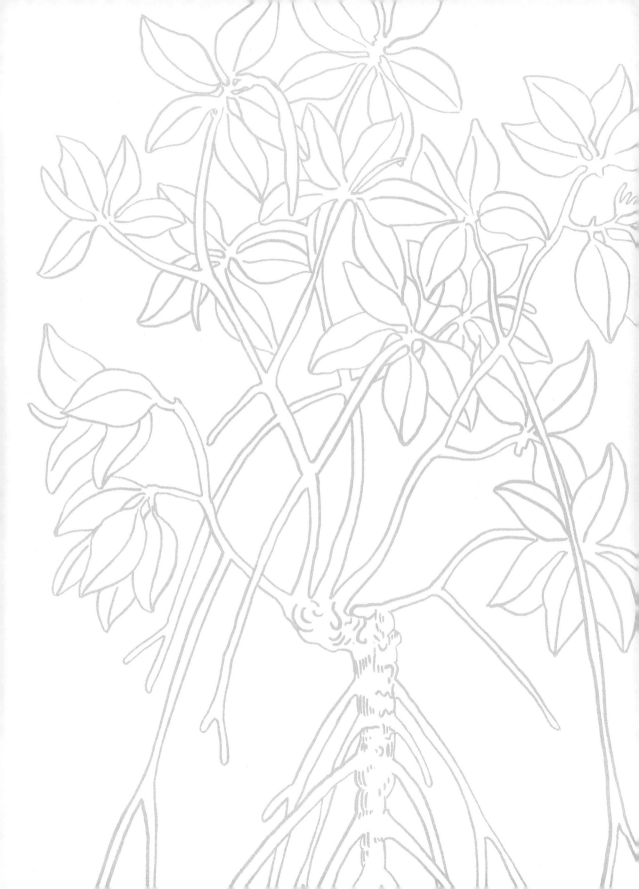

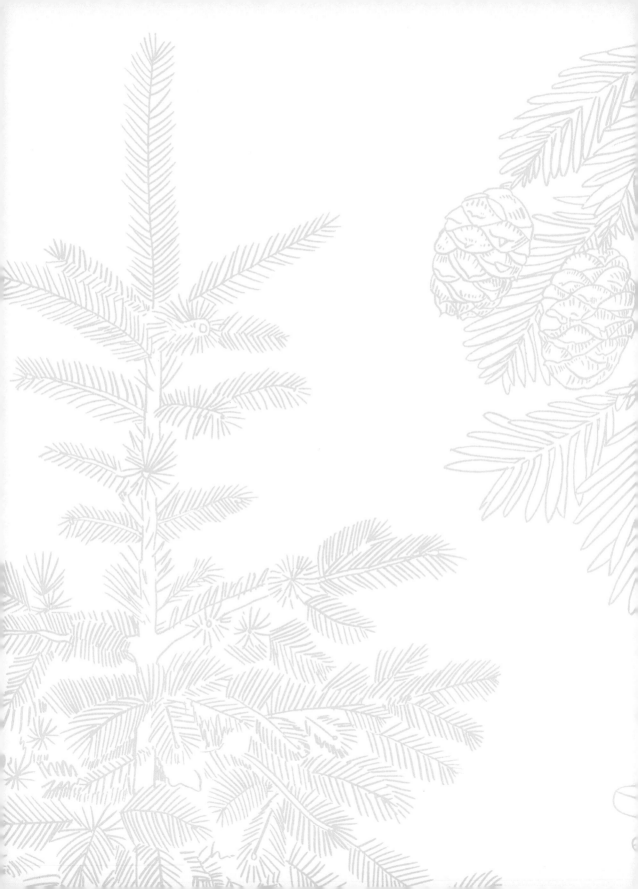

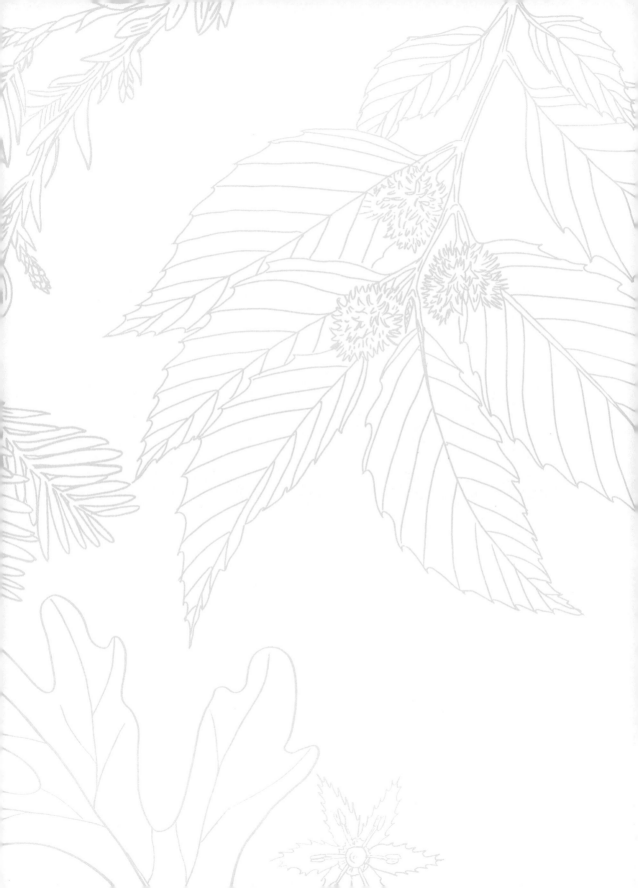

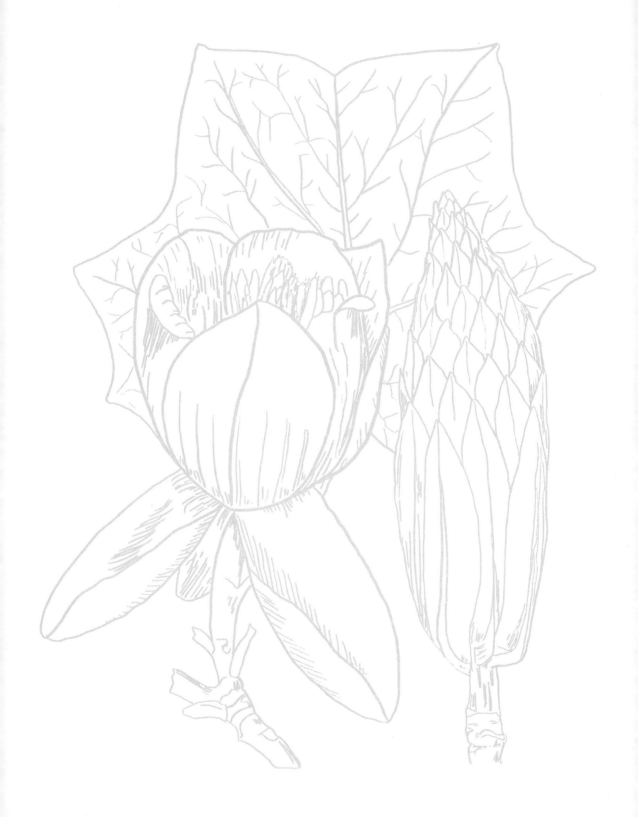

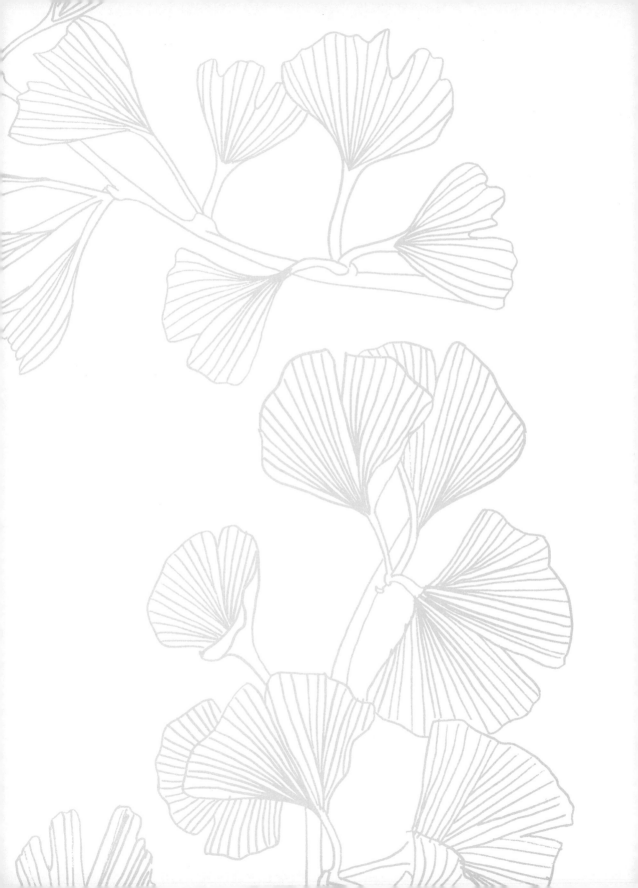

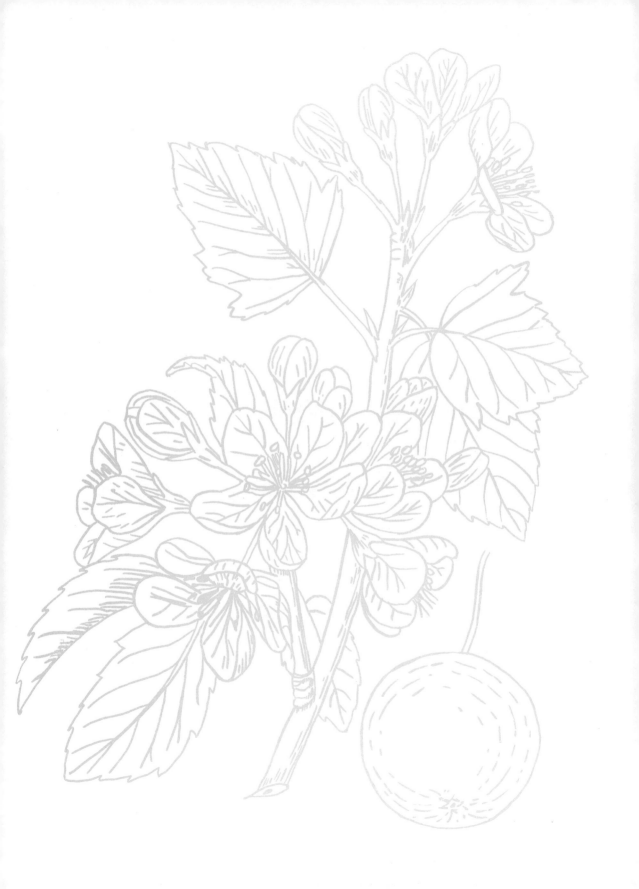

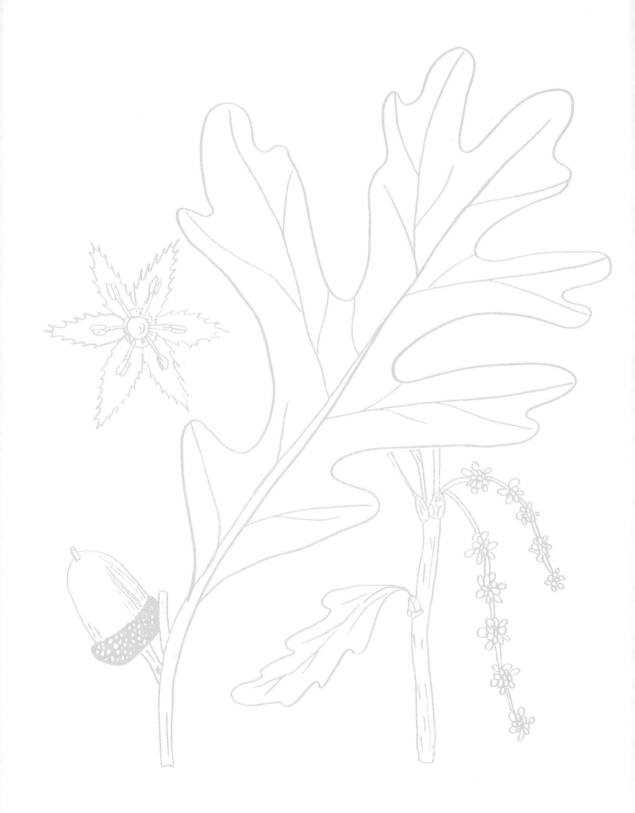

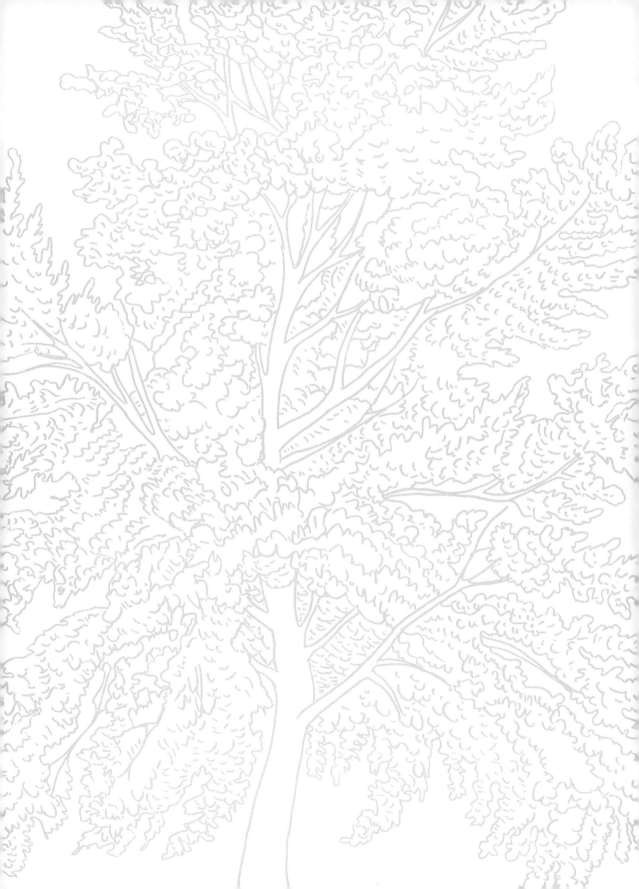

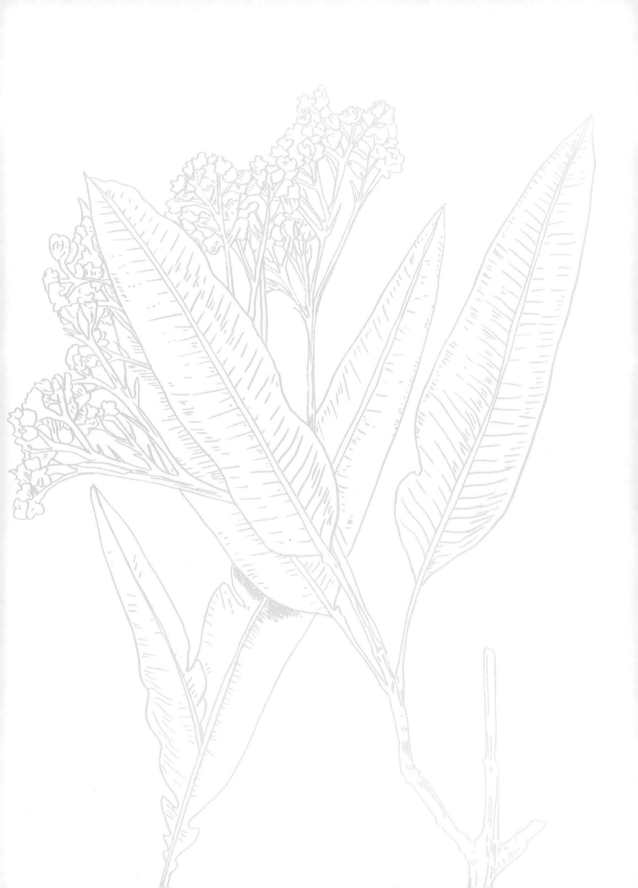

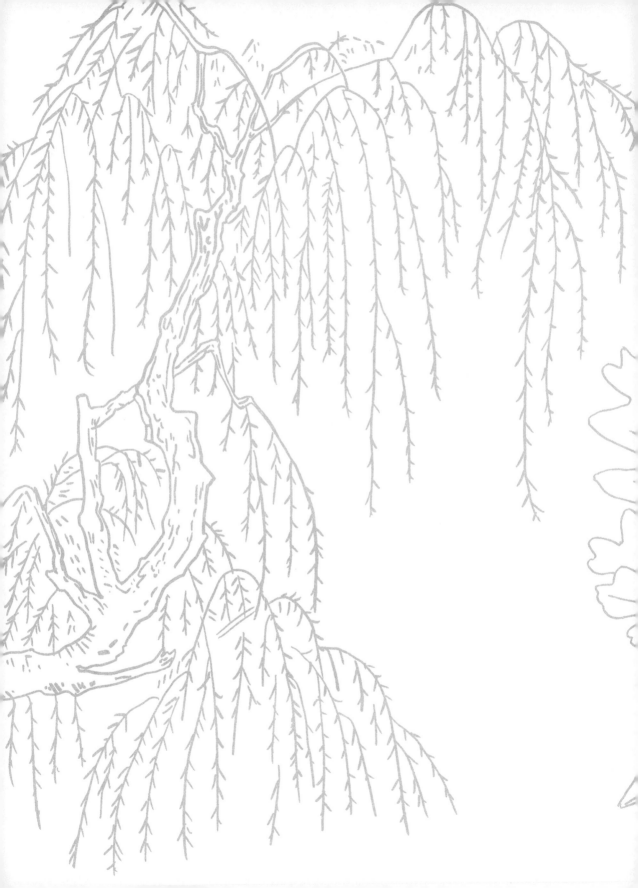

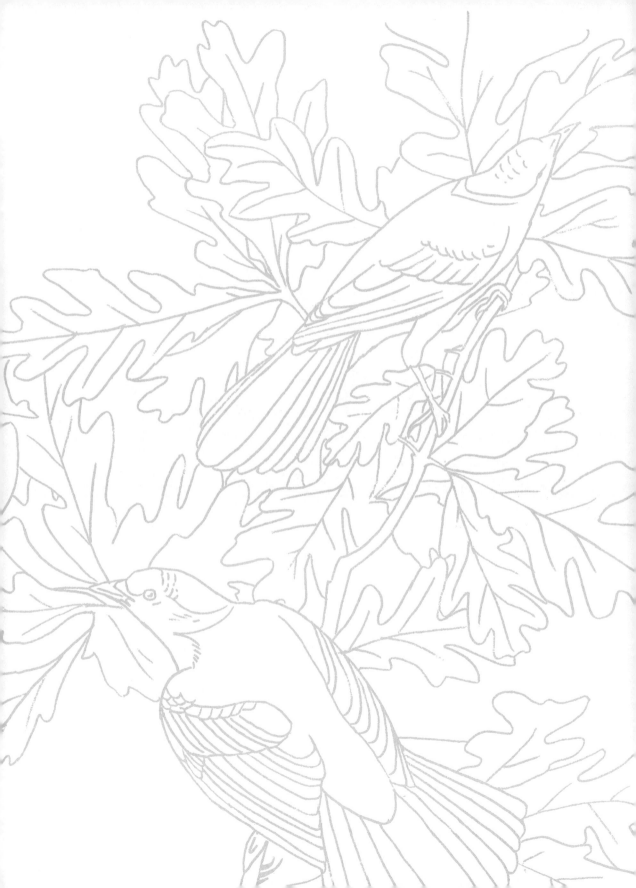

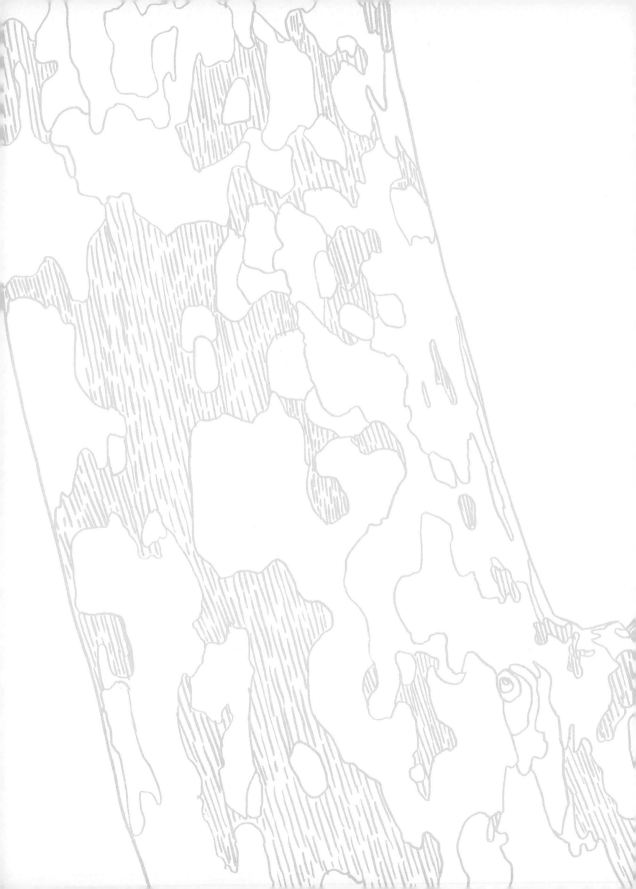

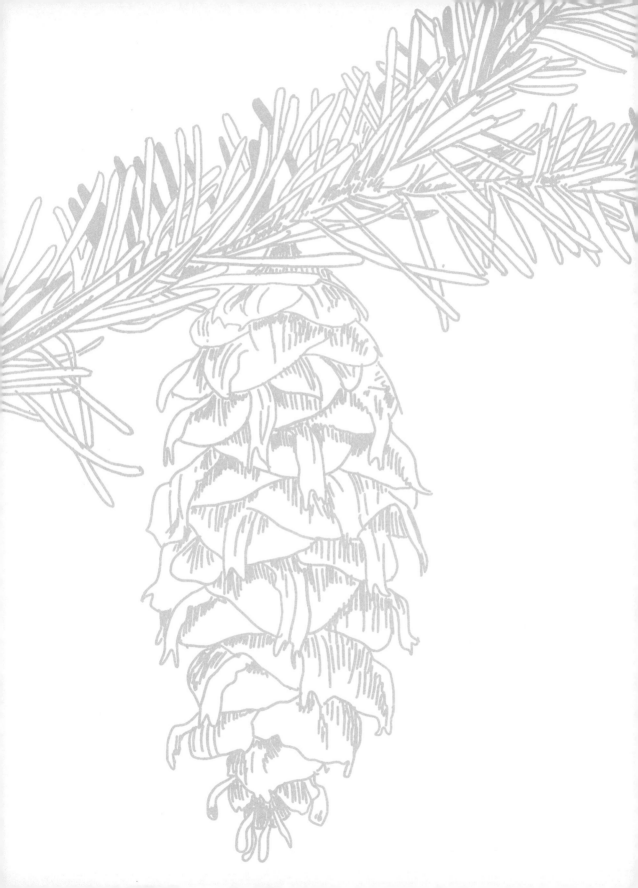

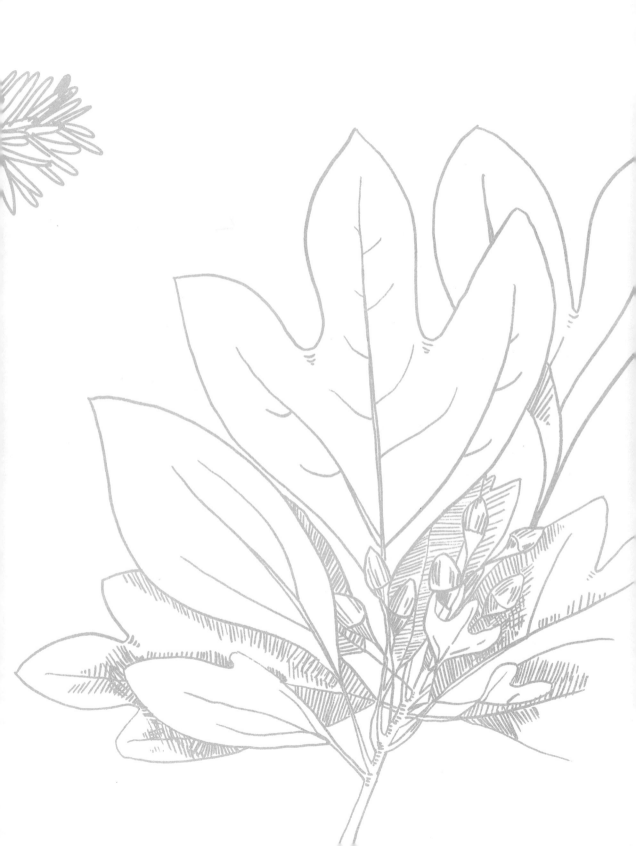

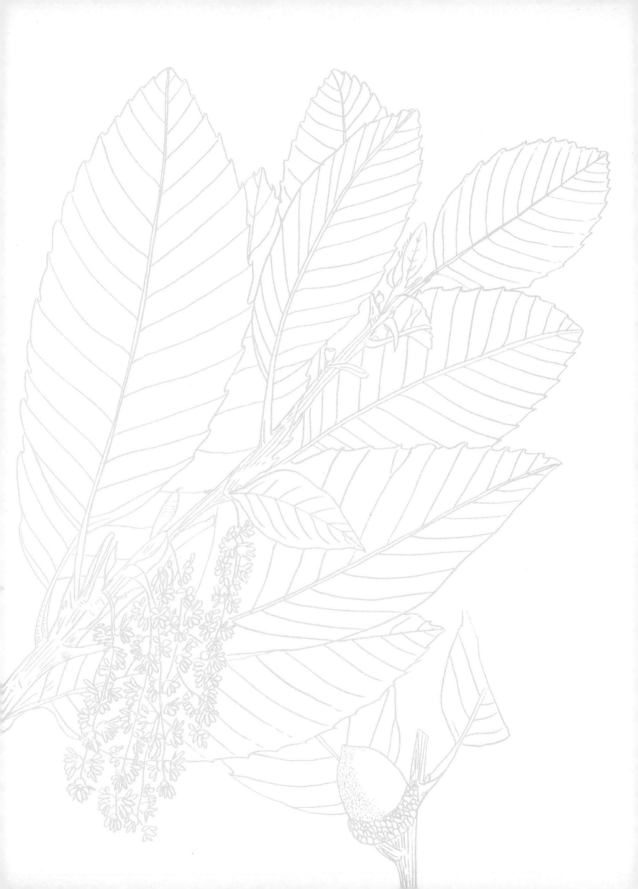

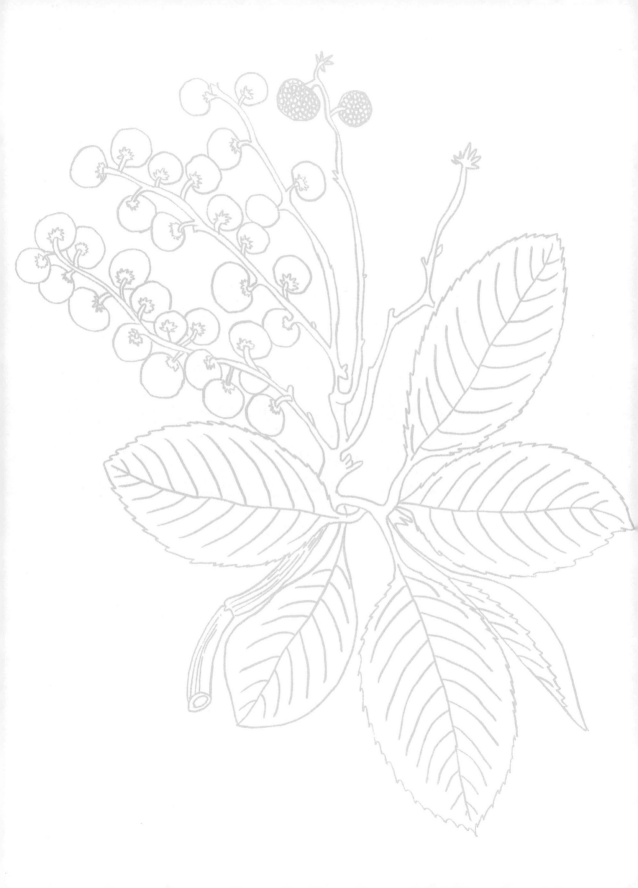

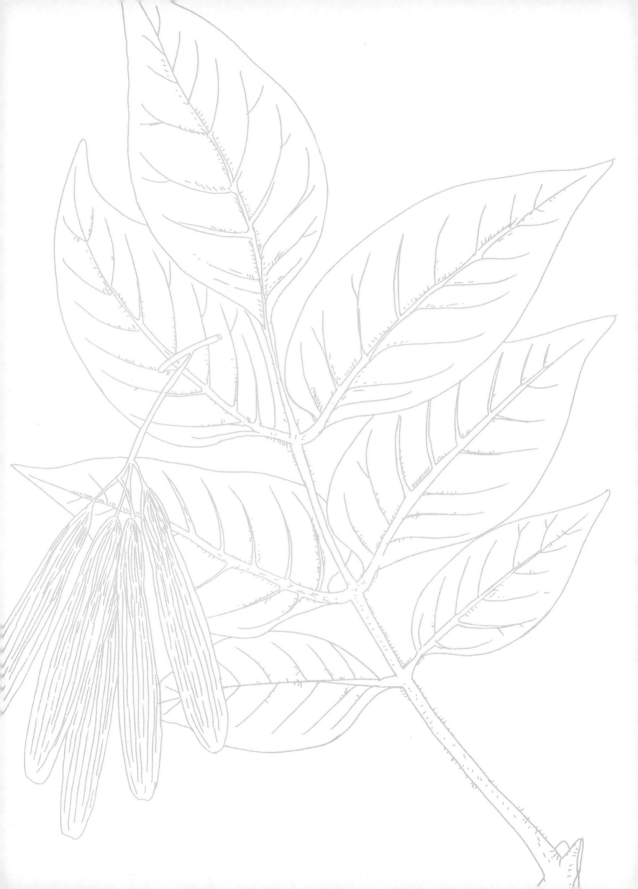

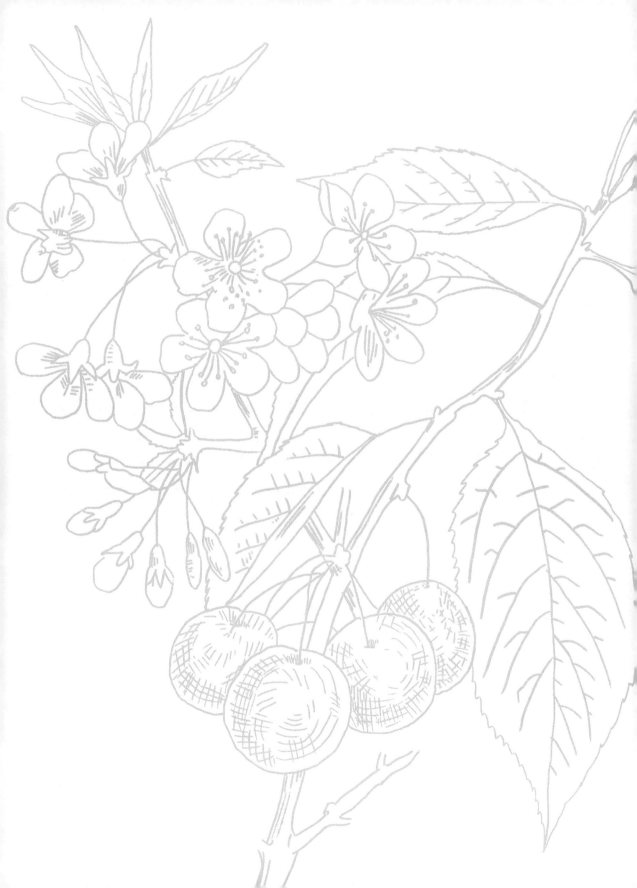

NOTES

NOTES

NOTES

NOTES

Leah Koransky is a designer and artist
living in Northern California
www.leahkoransky.com

Princeton Architectural Press
202 Warren Street, Hudson, NY 12534
www.papress.com

ISBN 978-1-64896-124-3
Manufactured in China
10 9 8 7 6 5 4 3 2 1

Editor: Sara McKay
Content, illustrations, design: Leah Koransky